Cool Restaurants Hamburg

teNeues

Imprint

Editor:	Sabina Marreiros
Photos (location):	Markus Bachmann (Abendmahl, Atlas, Au quai, Bar Hamburg, Bar Rossi, Brook, China Lounge, Da Caio Ristorante & Bar, Das weiße Haus, Doc Cheng's, Eisenstein, IndoChine, Le Ciel Restaurant et Bar, Nil, Sands, Süllberg Bistro, Turnhalle St. George, Vapiano, WA–YO, Weite Welt), Dirk Bartling (Bereuther), Klaus Frahm/artur (D Welt ist schön), Hans Hansen (Saliba), Courtesy Henssler & Henssle Verena Kallweit (4experiment Gastraum), Roland Klemp (Cox), Veit Müller (Saliba), Ute Schenk (Bereuther)
Introduction:	Christian Schönwetter
Layout & Pre-press:	Thomas Hausberg
Imaging:	Jan Hausberg
Translations:	AS CO international
	Nina Hausberg (English / recipes)

Produced by fusion publishing GmbH
www.fusion-publishing.com

Published by teNeues Publishing Group

teNeues Publishing Company
16 West 22nd Street, New York, NY 10010, USA
Tel.: 001-212-627-9090, Fax: 001-212-627-9511

teNeues Book Division
Kaistraße 18, 40221 Düsseldorf, Germany
Tel.: 0049-(0)211-994597-0, Fax: 0049-(0)211-994597-40

teNeues Publishing UK Ltd.
P.O. Box 402, West Byfleet, KT14 7ZF, Great Britain
Tel.: 0044-1932-403509, Fax: 0044-1932-403514

teNeues France S.A.R.L.
4, rue de Valence, 75005 Paris, France
Tel.: 0033-1-55766205, Fax: 0033-1-55766419

www.teneues.com

ISBN:	ISBN 3-8238-4599-3

© 2004 teNeues Verlag GmbH + Co. KG, Kempen

Printed in Germany

Bibliographic information published by
Die Deutsche Bibliothek. Die Deutsche Bibliothek lists this publication in the Deutsche Nationalbibliografie; detailed bibliographic data is available in the Internet at http://dnb.ddb.de.

Contents

Page

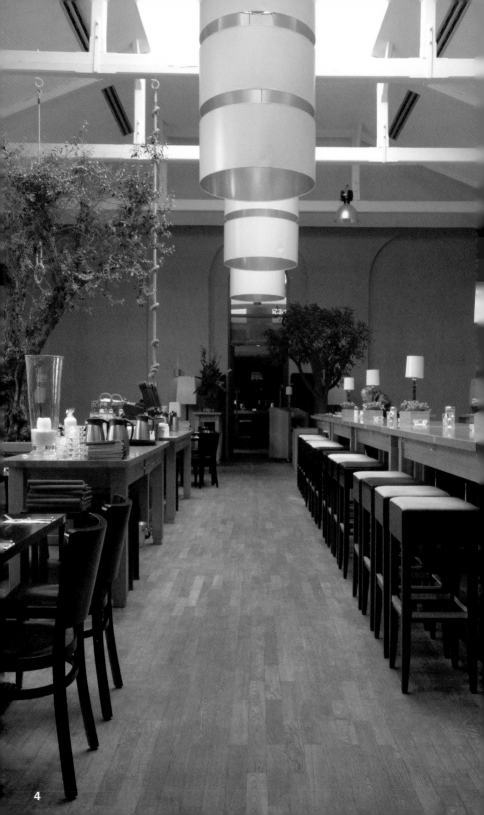

Einleitung

Hamburgs Gastronomen sind eigentlich nicht zu beneiden: Die berühmteste Spezialität der Stadt, der „Hamburger", der im 19. Jahrhundert mit deutschen Auswanderern nach Amerika gelangte, eignet sich nicht gerade besonders gut als kulinarisches Aushängeschild der hanseatischen Küche. Diese hat natürlich sehr viel mehr zu bieten als einfaches Fast Food. In einer Stadt von Welt finden sich selbstverständlich auch Restaurants aus aller Welt. Liebhaber jeglicher Kochkunst – und vor allem jeglichen Esstempos – kommen auf ihre Kosten. Sowohl quirlige Tapas-Bars, als auch kontemplative japanische Restaurants oder angesagte Dine-and-Dance-Locations erwarten den Besucher. Und auch die Auswahl an Bars, Cafés und Lounges hält für jeden etwas bereit. Doch beim Ausgehen ist nicht nur das „Was", sondern auch das „Wo" entscheidend. Hier bietet Hamburg mit seiner Lage am Wasser viele außergewöhnliche Lokalitäten am Elbufer, an der Alster oder am Hafen.

Während der Wirt das „Was" bestimmt, ist für das „Wo" der Architekt oder Designer zuständig, zumindest in der Szenegastronomie. Er soll Ideen für einen individuellen Ort entwickeln, der möglichst einladend auf die Besucher wirkt. Solche Räume zu entwerfen gehört wohl zu den schwierigsten Aufgaben für einen Gestalter. Es geht um besonders schwer fassbare Parameter; es geht darum, eine Atmosphäre, eine bestimmte Stimmung zu schaffen. Alle menschlichen Sinne sollen gezielt angesprochen werden. Besonders gelungen ist dies bei der Bar „Die Welt ist schön" in der Nähe von St. Pauli. Ein lauter Barbereich mit harten Stahl- und Betonoberflächen und kühlem bläulichem Licht steht im Kontrast zur ruhigen Loungezone mit weichen gepolsterten Lederwänden und mildem warmem Licht. Cool Restaurants Hamburg zeigt die 30 ungewöhnlichsten Orte dieser Art. Und damit der Besucher, wenn er wieder nach Hause kommt, wenigstens einen Teil seines gastronomischen Erlebnisses wieder aufleben lassen kann, verraten einige Küchenchefs, wie sie die Spezialität ihres Hauses zubereiten.

Christian Schönwetter

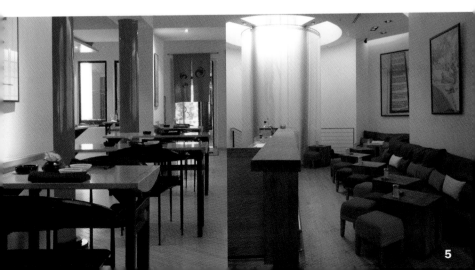

Introduction

You cannot envy Hamburg's restauranteurs. The city's most famous specialty, the "hamburger", which was taken to America by German emigrants, is not really suitable as a culinary advertisement of Hanseatic cuisine. This city has a lot more to offer than just plain fast food. Naturally, in an international city, you will find cuisines from throughout the world. Enthusiasts of all types of culinary arts, especially all eating speeds get their money's worth here. Lively tapas bars and contemplative Japanese restaurants as well as trendy dine and dance locations await the visitor. Something is available for everyone in the choice of bars, cafés, and lounges. When going out, not only "what" to eat but also "where" to go are of the utmost importance. As a result of its setting near the water, Hamburg offers many unusual areas along the banks of the River Elbe, the Alster, or near the harbor. While the restaurateur has the say as far as the "what" is concerned, the architect or designer is responsible for the "where", at least with regard to thematic design. Ideas are developed for an individual site to make it as inviting as possible to the visitor. Designing such areas is one of the most difficult tasks a designer can be confronted with. It involves especially complex tangible parameters, namely that of creating an atmosphere or a certain mood. All man's senses have to be specifically addressed. This has been especially successful in the case of the bar, "Die Welt ist schön" (the world is beautiful) near St. Pauli. A loud bar area with hard steel and concrete surfaces and cool blue lighting is used in contrast to the calm lounge area with soft upholstered leather walls and mild warm light.

Cool Restaurants Hamburg portrays the 30 most unusual locations of this kind. To ensure that the visitor can revive at least some of their culinary experiences after the return home, some of the chefs have even revealed how they prepare their restaurant's specialties.

Christian Schönwette

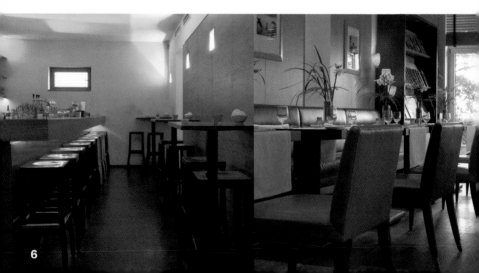

Introduction

En fait, les gastronomes de Hambourg ne sont pas à envier : La spécialité la plus connue de la ville, le « Hamburger », qui arriva en Amérique au 19ème siècle avec les émigrants allemands ne convient pas vraiment comme enseigne culinaire de la cuisine hanséatique. Celle-ci a naturellement beaucoup plus à offrir que du simple fast-food. Dans une ville cosmopolite, l'on trouve naturellement également des restaurants du monde entier. Les amateurs de tous les arts culinaires – et, surtout, de toutes les vitesses ou lenteurs du repas – ne seront pas déçus. Aussi bien des bars animés à tapas que des restaurants japonais contemplatifs ou des Dine-and-Dance-Locations à la mode attendent les hôtes. Et le choix de bars, cafés et Lounges en offre pour tous les goûts. Mais, lors d'une sortie, il n'y a pas que le « Quoi », le « Où » est également décisif. Ici, Hambourg, située au bord de l'eau, offre de nombreuses localités extraordinaires le long des berges de l'Elbe, le long de l'Alster ou au port.

Alors que le patron du restaurant décide du « Quoi », l'architecte ou le designer est responsable du « Où », du moins dans la gastronomie à la mode. Il doit développer des idées pour un endroit individuel qui doit paraître le plus attrayant possible aux hôtes. Concevoir de tels locaux fait certainement partie des tâches les plus compliquées pour un designer. Il s'agit de paramètres particulièrement difficiles à saisir ; il s'agit de créer une atmosphère, une certaine ambiance. Il faut s'adresser de façon ciblée à tous les sens humains. Ceci a particulièrement réussi dans le bar « Die Welt ist schön » (Le monde est beau) à proximité du quartier St. Pauli. Un secteur bar bruyant avec de dures surfaces en acier et en béton et un éclairage bleu froid contraste avec la zone tranquille de la Lounge avec ses murs recouverts de cuir rembourré et son éclairage doux et chaud.

Cool Restaurants Hamburg montre les 30 endroits les plus extraordinaires de ce genre. Et pour que l'hôte, lorsqu'il rentre chez lui, puisse faire revivre au moins une partie de cet événement gastronomique, quelques chefs révèlent comment ils préparent la spécialité de leur restaurant.

Christian Schönwetter

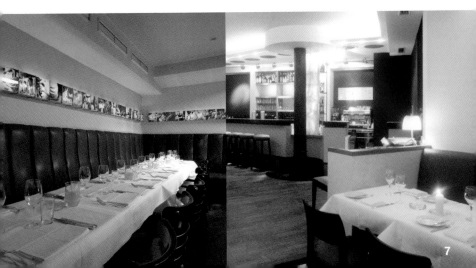

Introducción

No se puede envidiar a los gastrónomos de Hamburgo: la especialidad más conocida de la ciudad, "la hamburguesa", que en siglo XIX llegó a América con los emigrantes alemanes, no es precisamente la más apropiada como buen rótulo culinario de la cocina anseática. Por supuesto que ésta tiene muchísimo más que ofrecer que un simple Fast Food. En una metrópoli se encuentran evidentemente también restaurantes de todo el mundo. Los amantes de cualquier tipo de arte culinario –y sobre todo cualquier tipo de rapidez para comer– se sienten contentos. Tanto los bares de tapas llenos de vida, como también los contemplativos restaurantes japoneses o llamativas locaciones Dine-and-Dance esperan a los visitantes. Y para cada persona hay también siempre algo dispuesto con la variedad de bares, cafés y lounges. Sin embargo, para salir es decisivo no sólo el "qué", sino también el "dónde". Hamburgo con su ubicación al lado del agua ofrece en este sentido muchas localidades excepcionales a las orillas del Elba, en el Alster o en el puerto.

Mientras el dueño de un restaurante determina el "qué", el responsable del "dónde" es el arquitecto o el diseñador, por lo menos en la gastronomía de la movida cultural. Éste debe desarrollar ideas para un lugar individual, que en lo posible sea atrayente para los visitantes. Diseñar este tipo ambientes pertenece a una de las tareas más difíciles para un diseñador. Se trata de parámetros concretos especialmente complicados, se trata de lograr una atmósfera para un determinado estado de ánimo. Deben ser abordados en forma precisa todos los sentidos humanos. Esto se logró en forma especial en el bar "Die Welt ist schön" (El mundo es hermoso) en las cercanías de St. Pauli. Un área de bar ruidosa con superficies duras de acero y hormigón y luz fría azulada se pone en contraste con la tranquila zona del Lounge con blandas paredes en cuero acolchado y una cálida luz suave. Cool Restaurants Hamburg muestra los 30 lugares más insólitos de este tipo. Para que así el visitante, cuando regrese a su casa, pueda por lo menos volver a reavivar una parte de su experiencia gastronómica, revelamos además, cómo algunos jefes de cocina preparan la especialidad de su casa.

Christian Schönwetter

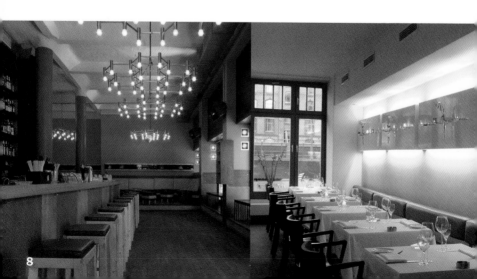

ntroduzione

gastronomi di Amburgo non sono certo da invidiare: La specialità più rinomata
lella città "Hamburger", che nel 19.mo secolo introdussero in America gli emi-
;ranti tedeschi, non si adatta molto bene come cartellone pubblicitario della cuci-
1a anseatica. Questa ha da offrire molto di più della semplice Fast Food. In una
;rande metropoli si trovano naturalmente anche ristoranti di ogni nazionalità.
\manti di ogni arte culinaria e soprattutto di ogni tempo possono soddisfare i loro
;usti. Tanto i vivaci Tapas-Bars, come pure i contemplativi ristoranti giapponesi o i
)ine-and-Dance-Locations di moda aspettano di accogliere i visitatori. E anche la
;celta dei bar, caffè e Lounge hanno qualcosa di pronto da offrire a tutti. Nell'u-
;cire è decisivo non c'è solo il "cosa", bensì anche il "dove". In questo, Amburgo
1ella suo posizione marina offre molte straordinarie località alle rive dell'Elba, all'-
\lster o al porto.
√lentre l'oste decide il "cosa" l'architetto o il designer è il competente per il "do-
'e" almeno nella gastronomia di scena. Egli deve sviluppare idee per una località
ndividuale, che abbia possibilmente l'effetto invitante sui visitatori. Progettare si-
nili spazi fa parte dei più difficili compiti per un ideatore. Si tratta qui di creare
)arametri concreti, atmosfere e umori particolarmente difficili. Tutti i sensi umani
levono essere mirati a commuovere. Questo è particolarmente riuscito nel bar
'Die Welt ist schön"(Il mondo è bello) nei pressi di S.Pauli. Uno spazio di bar ru-
noroso con superfici di duro calcestruzzo in acciaio e fredde luci bluastre è in
:ontrasto con la quieta zona lounge con morbide pareti imbottite di pelle e tenue
: calda luce.
Cool Restaurants Hamburg mostrano i 30 luoghi più straordinari di questo tipo. E
:on questo il visitatore, quando torna a casa, può rivivere per lo meno una parte
lelle sue esperienze gastronomiche svelato da alcuni cuochi come loro preparano
e specialità delle loro case.

Christian Schönwetter

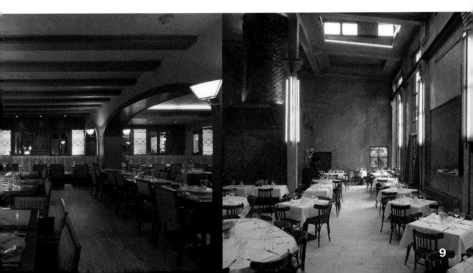

4experiment Gastraum

Design: 4experiment | Chef: Matthias Gfrörer, Raik Holst,
Torsten Schmidt, Jürgen Zimmerstädt

Karolinenstraße 32 | 20357 St. Pauli
Phone: +49 40 43 18 84 32
www.4experiment.de
Subway: Messehallen
Opening hours: Mon–Sat 7 pm to open end
Average price: € 14
Cuisine: Crossover, classical

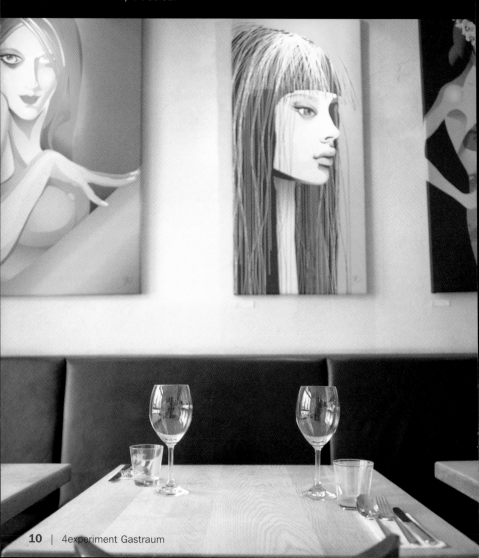

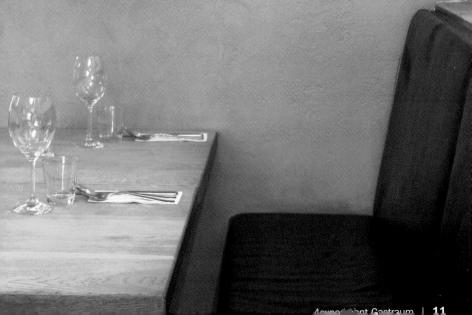

‡ ☆ Getränke

		2,00
...ta	0,33	2,50
...matscher Pils	0,5	3,50
...ersteplauer Hefe	0,4	3,00
...ls (alkoholfrei)	0,33	2,50
...et. cremant de loire	0,1	4,50
	0,2	2,00
...ola	0,25	2,50
...gina	0,33	2,50
...aden	0,2	1,80
...te	0,4	2,50
...elschorle	0,4	2,50
...alba fritzcola/fashion	0,75	4,00
		2,00
...uccino		2,50
...macchiato		2,50
...sso / doppio		1,50/2,50
...esso macchiato		2,00
...mo corretto		2,80
...e (nach Angebot)		2,00 €

Marinierter
Ziegenkäse
mit kreolischen Gemüsen

Marinated Goatcheese with Creole Vegetables

Fromage de chèvre mariné avec légumes créoles

Queso de cabra escabechado con verduras criollas

Formaggio di caprino marinato con verdure di creola

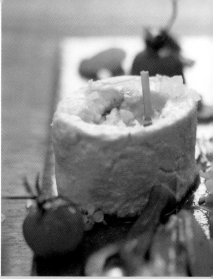

4 Stücke Ziegenkäse (à ca. 50 g)
Marinade für den Ziegenkäse: 5 EL Olivenöl, je 1 Zweig Rosmarin und Thymian, 1 zerdrückte Knoblauchzehe, 1 halbierte Chilischote
100 g Kumquats (Mini-Orangen)
1 rote Chilischote
250 g brauner Zucker
5 EL Rotweinessig
5 EL Olivenöl
Salz, zerstoßene schwarze Pfefferkörner
1 Prise Zimt
200 g Okraschoten
20 mittelgroße Kirschtomaten
1 EL Öl
1 mittelgrosse rote Zwiebel
Grobes Meersalz
Senfblüten zum Garnieren
Ziegenkäse über Nacht bei Raumtemperatur marinieren. Kumquats und Chili waschen, putzen und längs halbieren. Zucker mit 1/4 l Wasser aufkochen und die Kumquats und Chili darin 10-15 Minuten

köcheln lassen. Danach herausnehmen und Ch grob hacken. Essig mit drei EL der Kochflüssigke verrühren. Mit Salz, Pfeffer und Zimt abschmecke Restliches Olivenöl einrühren. Kumquats und Ch zufügen und ziehen lassen. Okraschoten un Kirschtomaten putzen. Öl in einer Pfanne erhitze und die Schoten darin ca. fünf Minuten anbrate Herausnehmen und mit Salz und Pfeffer würze Nun die Kirschtomaten anbraten bis die Haut leic platzt. Herausnehmen und mit Salz und Pfeffer wü zen. Zwiebeln in dünne Ringe schneiden, mit Sa und Pfeffer würzen und mit dem restlichen Essi und dem Öl marinieren. Ziegenkäse aus de Marinade nehmen, mit etwas Meersalz bestreue und mit Okraschoten, Kirschtomaten und Zwie belringen anrichten. Mit der Kumquat-Vinaigrett beträufeln und mit Senfblüten garnieren.

4 pieces goatcheese (1/2 oz each)
For the marinade: 5 tbsp olive oil, 1 twig rosemary, 1 twig thyme, 1 glove of garlic, crushed, 1/2 chilipod
4 oz kumquats (mini oranges)
1 red chilipod
9 oz brown sugar
5 tbsp redwine vinegar
5 tbsp olive oil
Salt, crushed black pepper
1 dash cinnamon
7 oz okra
20 cherry tomatoes
1 tbsp oliveoil
1 medium red onion
Sea salt
Mustard flowers
Marinate goatcheese over night. Wash kumquats and chilli, and cut in half. Bring sugar and 250 ml water to a boil and let kumquats and chili simmer for 10 minutes. Take out and mince chili. Combine three tbsp of fond with vinegar, season with salt,

pepper and cinamon. Stir in olive oil. Marinad kumquats and chilli. Chill. Wash okras and toma toes. Heat one tbsp oil in a pan and fry okra for fiv minutes. Take out and season. Fry tomatoes, unt the skin bursts. Take out and season. Cut onion i thin rings and season with salt and pepper. Remov the goatcheese from the marinade, sprinkle wit sea salt and garnish with okra, tomatoes and onio rings. Drizzle with kumquat-vinaigrette and decora te with mustard flowers.

morceaux de fromage de chèvre (d'env. 50 g)
Marinade pour le fromage de chèvre : 5 c. à soupe
d'huile d'olive, 1 branche de romarin, 1 branche de
thym, 1 gousse d'ail écrasée, 1 piment coupé en
deux
100 g kumquats (mini oranges)
1 piment rouge
250 g de sucre brun
5 c. à soupe de vinaigre de vin rouge
5 c. à soupe d'huile d'olive
Sel, poivre noir en grains concassés
1 prise de cannelle
200 g d'ocras
20 tomates cerises de taille moyenne
1 c. à soupe d'huile
1 oignon rouge de taille moyenne
Gros sel de mer
Fleurs de moutarde pour la garniture
Faire mariner le fromage une nuit à température
ambiante. Laver les kumquats et le piment et les
couper en deux dans le sens de la longueur. Faire

cuire le sucre dans 1/4 l d'eau et laisser mijoter les
kumquats et le piment pendant 10 à 15 minutes
dans le sucre. Les retirer et hacher grossièrement le
piment. Mélanger le vinaigre avec 3 c. à soupe du
liquide de cuisson. Assaisonner avec le sel, le poi-
vre et la cannelle. Ajouter l'huile d'olive en remuant.
Ajouter les kumquats et le piment et laisser mariner.
Nettoyer les ocras et les tomates cerises. Faire
chauffer une c. à soupe d'huile dans une poêle et
faire frire les ocras pendant env. cinq minutes. Les
retirer et les assaisonner avec du sel et du poivre.
Faire frire les tomates cerises jusqu'à ce que la
peau éclate légèrement. Les retirer et les assaison-
ner avec du sel et du poivre. Couper l'oignon en
fines rondelles, les assaisonner avec du sel et du
poivre et les faire mariner. Retirer le fromage de
chèvre de la marinade, le saupoudrer avec un peu
de sel de mer et dresser avec les ocras, les toma-
tes cerises et les rondelles d'oignon. Ajouter quel-
ques gouttes de la vinaigrette aux kumquats et gar-
nir avec les fleurs de moutarde.

4 trozos de queso de cabra (aprox. 50 g)
Escabeche para el queso de cabra: 5 cucharadas
de aceite de oliva, 1 rama de romero, 1 rama tomi-
llo, 1 diente de ajo machacado, 1 un chili partido
por la mitad
100 g de kumquats (mini-naranjas)
1 chili rojo
250 g de azúcar marrón
5 cucharadas de vinagre de vino tinto
5 cucharadas de aceite de oliva
Sal, algunos granos de pimienta negra triturados
1 pizca de canela
200 g de vainas de ocra
20 tomates cherry medianos
1 cucharada de aceite
1 cebolla roja mediana
Sal marina de grano grueso
Flores de mostaza para decorar
Escabechar el queso de cabra durante una noche a
temperatura ambiente en los ingredientes mencio-
nados arriba. Lavar las mini-naranjas (kumquat) y el

chili, limpiarlos y partirlos a lo largo por la mitad.
Poner a hervir el azúcar con 1/4 l de agua y dentro
del líquido hervir a fuego lento las kumquat y el chili
durante 10-15 minutos. Luego retirarlos del fuego
y cortar el chili en trozos no muy pequeños. Mezclar
el vinagre con tres cucharadas del líquido cocinado.
Sazonarla con sal, pimienta y canela. Mezclar con
aceite de oliva. Añadir las kumquat y el chili y dejar
reposar. Limpiar las vainas de ocra y los tomates
cherry. Calentar una cucharada de aceite en la sar-
tén y freír en el las vainas aprox. cinco minutos.
Sacarlas y sazonarlas con sal y pimienta. Ahora freír
los tomates cherry hasta que se les reviente la piel.
Sacar y sazonar con sal y pimienta. Cortar la cebo-
lla en anillos finos, sazonarla con sal y pimienta y
escabecharla. Retirar el queso de cabra del esca-
beche, espolvorearlo con un poco de sal y servirlo
con las vainas de ocra, los tomates cherry y los ani-
llos de cebolla. Salpicarlo con la salsa de kumquat
y decorarlo con flores de mostaza.

4 Pezzi di formaggio di caprino (ca. 50 g ognuno)
Marinata per il formaggio di caprino: 5 cucchiai di
olio d'oliva, 1 rametto di rosmarino, 1 rametto di
timo, 1 spicchio d'aglio schiacciato, 1 peperonci-
no dimezzato
100 g di kumquats (arancini)
1 peperoncino
250 g di zucchero marrone
5 cucchiai di aceto di vino rosso
5 cucchiai di olio di oliva
Sale, chicchi di pepe nero schiacciato
1 pizzico di cannella
200 g di baccelli di ocra
20 pomodorini
1 cucchiaio di olio
1 cipolla rossa di media grandezza
Sale di mare grosso
Fiori di senape per guarnire
Marinare il formaggio per una nottata a tempera-
tura ambiente. Lavare il kumquats e il peperonci-
no, pulirlo e tagliarlo in lungo. Far bollire lo zuc-

chero con 1/4 l di acqua ed immergervi il kumquats
e il peperoncino e far cuocere a bollore debole per
10-15 minuti. Togliere il tutto e tagliuzzare il
peperoncino grossolanamente. Mescolare l'aceto
con il liquido bollito. Insaporire con sale, pepe e
cannella. Rimescolare l'olio d'oliva aggiungere
kumquats e peperoncino e lasciare in infusione.
Pulire i baccelli di ocra e i pomodorini. Scaldare un
cucchiaio di olio in una padella ed aggiungervi i
baccelli e friggere per cinque minuti. Toglierli dalla
padella ed insaporirli con sale e pepe. Friggere ora
i pomodorini fino a che la pelle si stacchi facil-
mente. Toglierli dal fuoco ed insaporirli con sale e
pepe. Tagliare le cipolle in anelli, insaporire con
sale e pepe e marinarli. Togliere il formaggio di
caprino dalla marinata, cospargerli con poco sale
ed allinearli con baccelli di ocra, pomodorini e
anelli di cipolla. Versarvi alcune gocce di kumquat-
vinaigrette e guarnire con fiori di senape.

Abendmahl

Chef: Christian Voigt

Hein-Köllisch-Platz 6 | 20359 St. Pauli
Phone: +49 40 31 27 58
Subway: Reeperbahn
Opening hours: Every day 6 pm to open end, kitchen open 7 pm to 11:30 pm
Average price: € 16
Cuisine: Modern

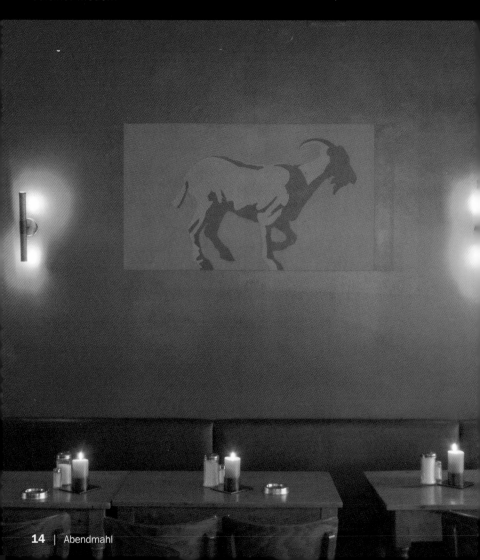

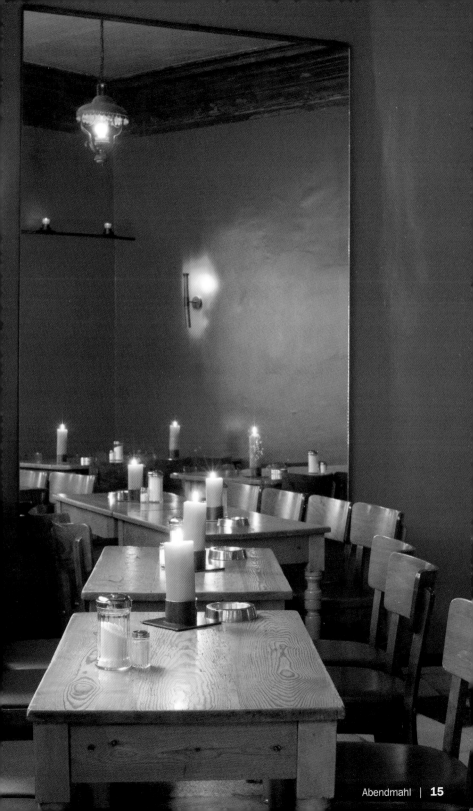

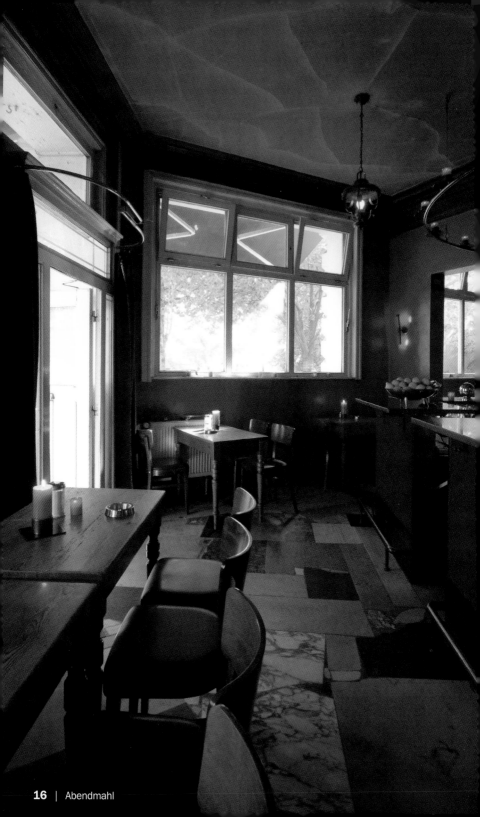

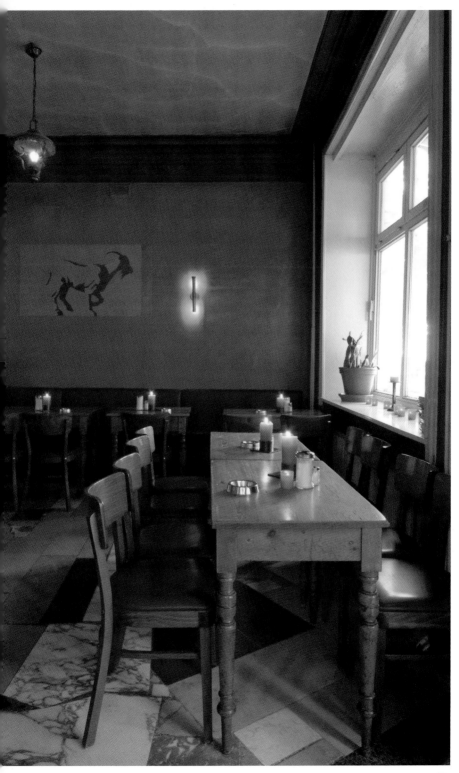

Atlas

Design: Rainer Wendt, Jürgen Renken
Chef: Martin Franciskowsky

Schützenstraße 9a / Phoenixhof | 22761 Bahrenfeld
Phone:+49 40 8 51 78 10
www.atlas.at | atlas@atlas.at
Subway: Diebsteich
Opening hours: Every day kitchen open 12 noon to 11 pm,
Sun Brunch 10:30 am to 3 pm
Menu price: Lunch € 9, Dinner € 16
Cuisine: New International

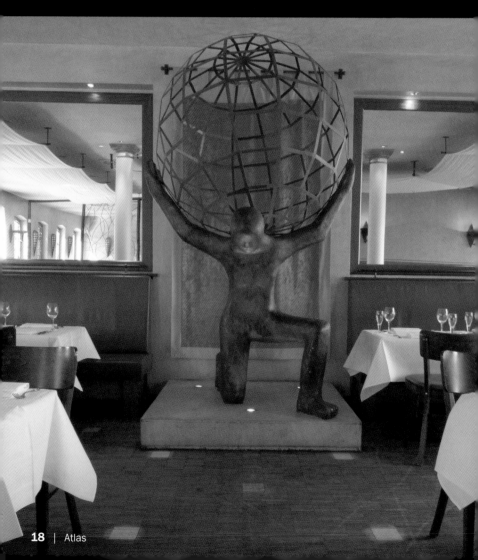

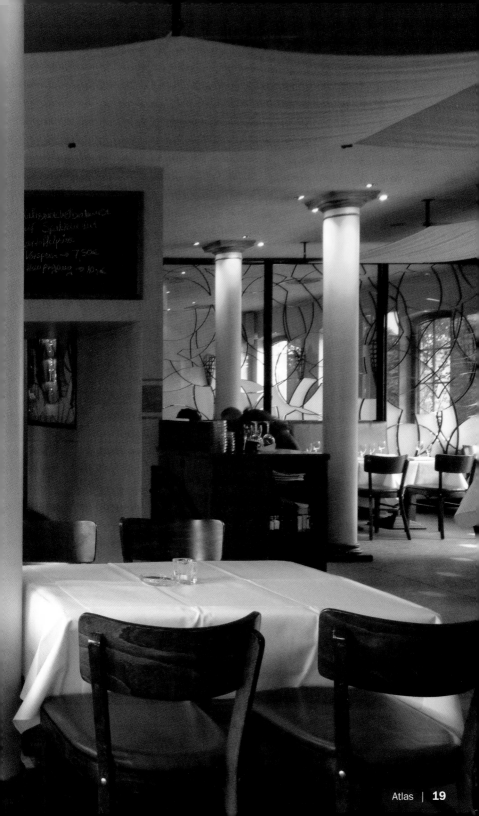

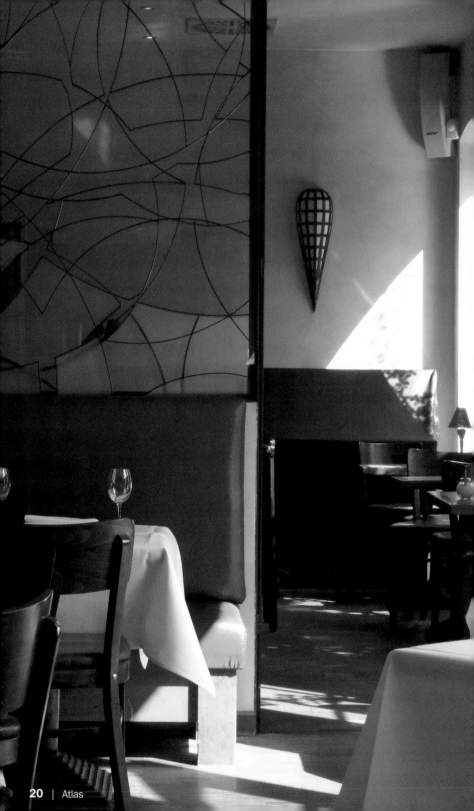

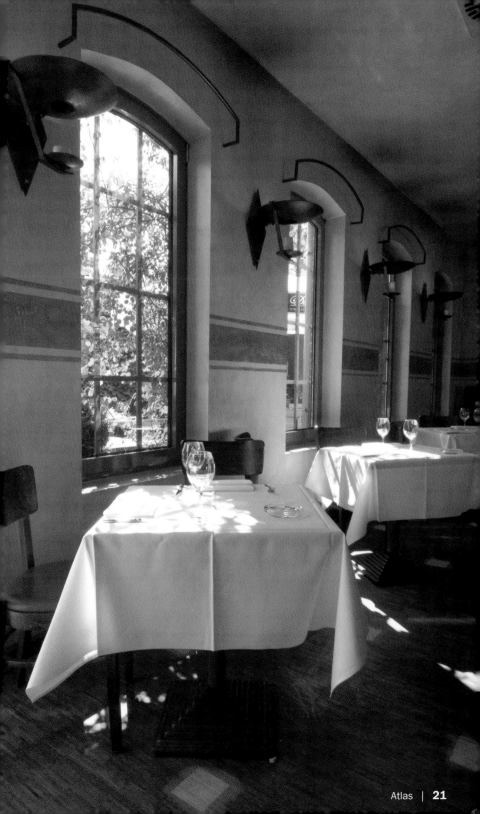

Au quai

Design: von Gerkan, Marg und Partner Architects
Interior: Enzo & Sylvianne Caressa | Chef: Matthieu Puillon

Große Elbstr. 145 b-d | 22767 Altona
Phone: +49 40 38 03 77 30
www.au-quai.com | info@au-quai.de
Subway: Königstraße, Landungsbrücken
Opening hours: Mon–Fri 12 noon to 3 pm, 6 pm to open end,
Kitchen open from 6 pm to 10:30 pm
Menu price: € 19–34
Cuisine: Mediterranean with Asian accent

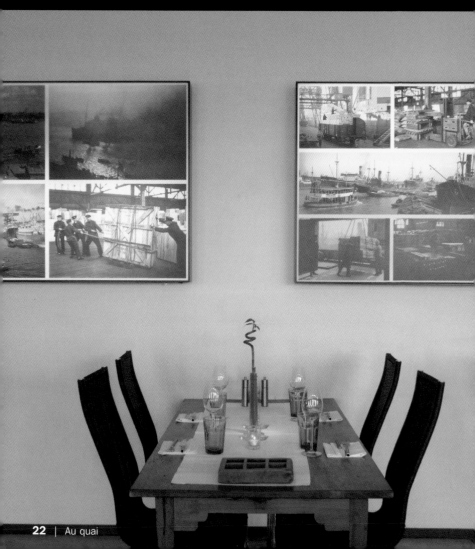

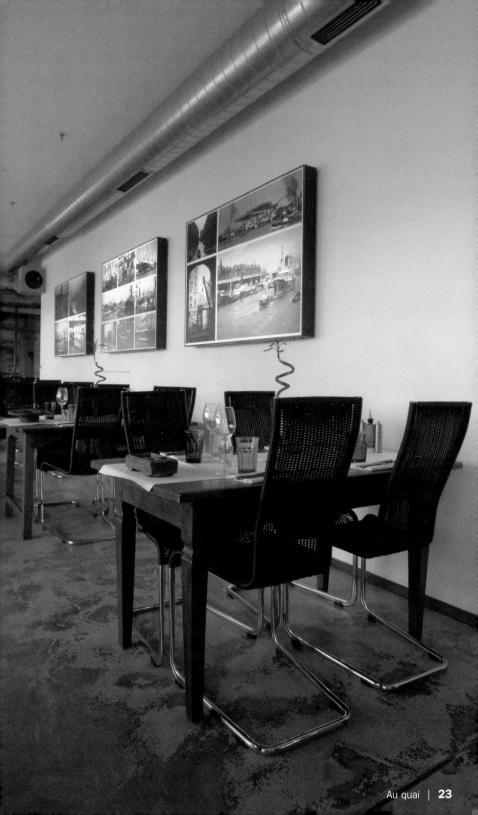

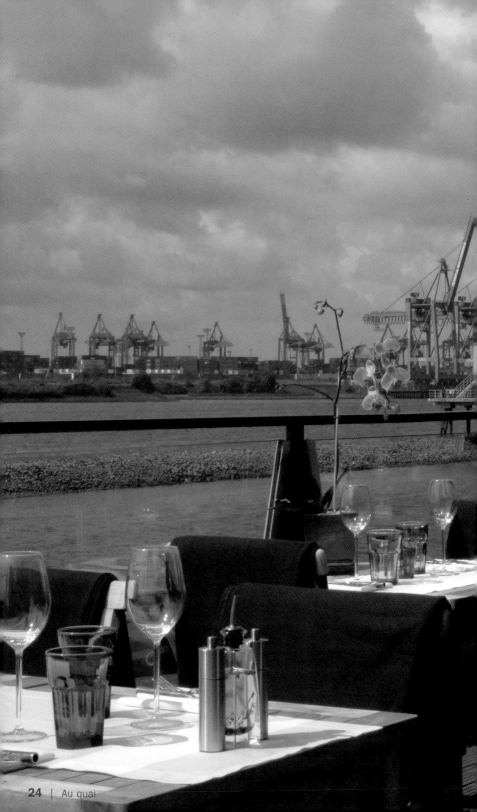

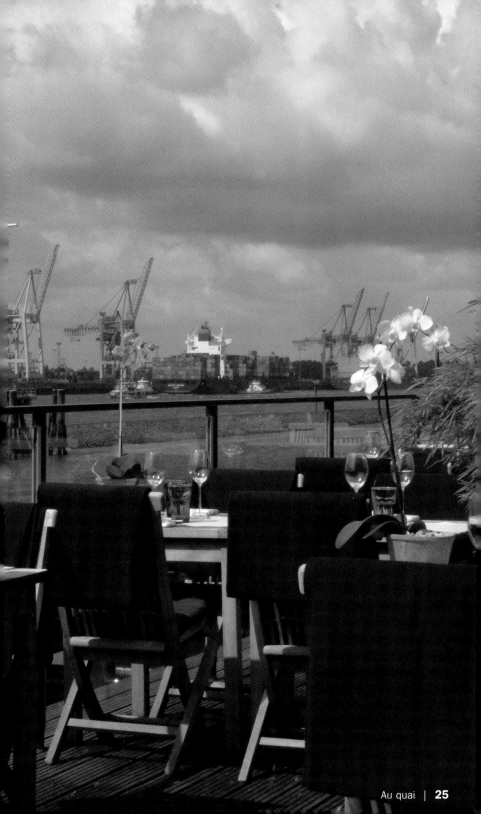

Mille Feuille
vom Rinderfilet und Feige

Mille Feuille of Beef Filet and Figs
Millefeuille de filet de bœuf aux figues
Mille feuille de filete de vaca e higo
Mille feuille di filetto di manzo e fico

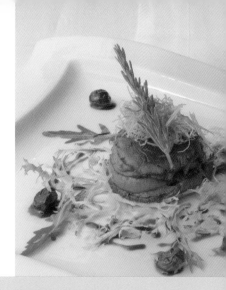

Rote und weiße Weintrauben (je 8 Stück)
2 EL brauner Zucker
2 EL Butter
400 ml roter Portwein
100 ml Orangensaft
1 Vanilleschote
2 Sternanis
4 Feigen
200 g Rinderfilet
2 EL Koriandersamen
2 EL weiße Pfefferkörner
1 Kopf Friséesalat
1 EL Meersalz
Balsamicoessig
Olivenöl

Trauben bei 70 °C ca. sechs Stunden trocknen.
Butter mit dem braunen Zucker karamellisieren
lassen, mit Portwein und Orangensaft ablöschen,
Vanilleschote und Sternanis dazugeben und z
Sirup einkochen lassen. Feigen schälen und
Scheiben schneiden, im Sirup einlegen.
Rinderfilet in zerstoßenem Pfeffer und Koriand
wälzen und von allen Seiten scharf anbrate
Kaltstellen.
Vom Friséesalat nur das Weiße abzupfe
waschen und trockentupfen. In der Mitte d
Tellers anrichten. Das Rinderfilet in dünn
Scheiben schneiden und mit dem Siru
Balsamicoessig, Olivenöl und Meersalz bestre
chen. Rinderfilet und Feigen schichtweise a
dem Salat anrichten, mit Rinderfilet abschließe
Die Trauben mit dem restlichen Sirup mische
und auf dem Teller verteilen. Mit Balsamicoess
und Olivenöl beträufeln.

Red and white grapes (about 8 pieces each)
2 tbsp brown sugar
2 tbsp butter
400 ml red porto
100 ml orangejuice
1 vanilla beam
2 star anis
4 figs
7 oz beef filet
2 tbsp whole coriander seed
2 tbsp white pepper
1 head frissee lettuce
1 tbsp sea salt
Balsamic vinegar
Olive oil

Dry grapes at 160 °F for about six hours.
Combine butter and brown sugar in a pot and
heat until the sugar melts. Let brown and add
porto and orangejuice. Add vanilla beam and an
and reduce liquid to a syrup by cooking. Peel an
slice the figs. Put figs in syrup to marinate.
Toss beef filet in crushed pepper and coriand
and fry sharply from all sides. Chill.
Take only the white part of the frissee, clean ar
dry and arrange in the middle of the plate. C
beef filet in thin slices and brush with syrup, ba
samic vinegar, olive oil and sea salt. Stack bee
filet and figs on the salad, finish with the bee
Marinate grapes in the leftover syrup and sprea
evenly on the plate. Garnish with balsamic vin
gar and olive oil.

Raisin noir et blanc (8 grains de chaque)
2 c. à soupe de sucre brun
2 c. à soupe de beurre
400 ml de Porto rouge
100 ml de jus d'orange
1 gousse de vanille
2 anis étoilés
4 figues
200 g filet de bœuf
2 c. à soupe de coriandre en grains
2 c. à soupe de poivre blanc en grains
1 salade frisée
1 c. à soupe de sel de mer
Vinaigre balsamique
Huile d'olive

Faire sécher les raisons à 70 °C pendant env. six heures.
Faire caraméliser le beurre avec le sucre brun, le

déglacer avec le Porto et le jus d'orange, ajouter la gousse de vanille et l'anis étoilé et faire réduire pour obtenir un sirop. Eplucher les figues et les couper en tranches, les mettre dans le sirop. Rouler le filet de bœuf dans du poivre concassé et la coriandre et le faire rôtir de tous les côtés. Réserver au froid. Prendre uniquement les parties blanches de la salade frisée, les laver et les essuyer. La dresser au milieu de l'assiette. Couper le filet de bœuf en tranches fines et les enduire avec le sirop, le vinaigre balsamique, l'huile d'olive et le sel de mer. Dresser le filet de bœuf et les figues en couches sur la salade en terminant par le filet de bœuf. Mélanger le raisin avec le reste du sirop et les répartir sur l'assiette. Ajouter quelques gouttes de vinaigre balsamique et d'huile d'olive.

Uvas negras y blancas (8 de cada una)
2 cucharadas de azúcar marrón
2 cucharadas de mantequilla
400 ml de vino tinto de oporto
100 ml de zumo de naranja
1 rama de vainilla
2 unidades de anís estrellado
4 higos
200 g de filete de vaca
2 cucharadas de semillas de cilantro
2 cucharadas de granos de pimienta blanca
1 lechuga frisée
1 cucharada de sal marina
Vinagre balsámico
Aceite de oliva

Secar las uvas aprox. seis horas a 70 °C.
Dejar caramelizar la mantequilla con el azúcar marrón, rebajar con el vino de oporto y el zumo

de naranja, agregar la rama de vainilla y las estrellas de anís y dejar espesar al fuego hasta que se forme un jarabe. Pelar los higos y cortarlos en tajadas, ponerlos en el jarabe. Cubrir el filete de vaca en la pimienta y el cilantro machacado y sofreír fuerte por todos lados. Dejar enfriar. Arrancar sólo lo blanco de la lechuga frisée, lavarla y secarla tocándola ligeramente. Aderezarla en el centro del plato. Cortar el filete de vaca en lonchas finas y untarlo con el jarabe, vinagre balsámico, aceite de oliva y sal marina. Aderezar el filete de vaca y los higos en capas sobre la lechuga, la última capa con filete de vaca. Mezclar las uvas con el resto del jarabe y repartir en el plato. Salpicar con vinagre balsámico y aceite de oliva.

Uva bianca e nera (8 acini per ogni tipo)
2 cucchiai di zucchero marrone
2 cucchiai di burro
400 ml di Porto rosso
100 ml di succo d'arancia
1 baccello di vaniglia
2 stelle di anice
4 fichi
200 g di filetto di manzo
2 cucchiai di semi di coriandolo
2 cucchiai di chicchi di pepe
1 testa di insalata frisée
1 EL cucchiaio di sale di mare
Aceto balsamico
Olio d'oliva

Essiccare l'uva per sei ore a 70 °C circa.
Caramellare il burro con lo zucchero marrone, versare il Porto e il succo d'arancia, aggiungere i

baccelli di vaniglia e le stelle di anice e lasciar cuocere fino ad ottenere uno sciroppo. Sbucciare i fichi e tagliarli a fette, aggiungerli nello sciroppo. Passare il filetto di manzo nei chicchi di pepe schiacciati e nei semi di coriandoli e rosolare a fuoco vivo da tutti i lati. Far raffreddare. Staccare con le dita solo il bianco dell'insalata frisée, lavarla ed asciugarla. disporla nel mezzo del piatto. Tagliare il filetto in fette sottili e pennellarle con lo sciroppo, l'aceto balsamico, l'olio d'oliva e il sale di mare. Disporre il filetto di manzo e i fichi a strati sull'insalata, ultimare con il filetto di manzo. Mescolare l'uva con il resto dello sciroppo e distribuirla nel piatto. Versarvi alcune gocce di aceto balsamico e olio di oliva.

Bar Hamburg

Design: welovedesign.net

Rautenbergstraße 6-8 | 20099 St. Georg
Phone: +49 40 28 05 48 80
www.barhamburg.com | ahoi@barhamburg.com
Subway: Hauptbahnhof
Opening hours: Every day 7 pm to open end
Average price: Cocktails € 6
Cuisine: Barfood, cocktails

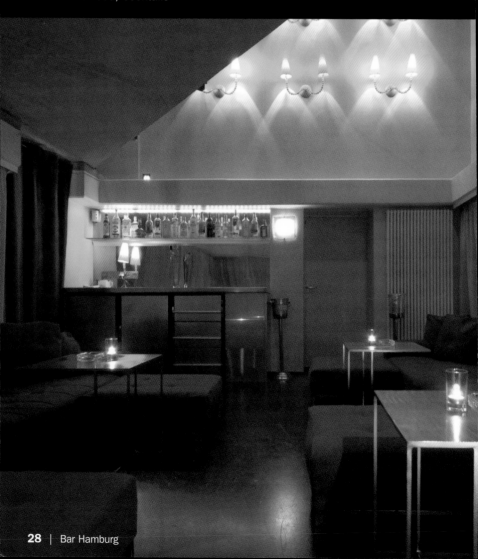

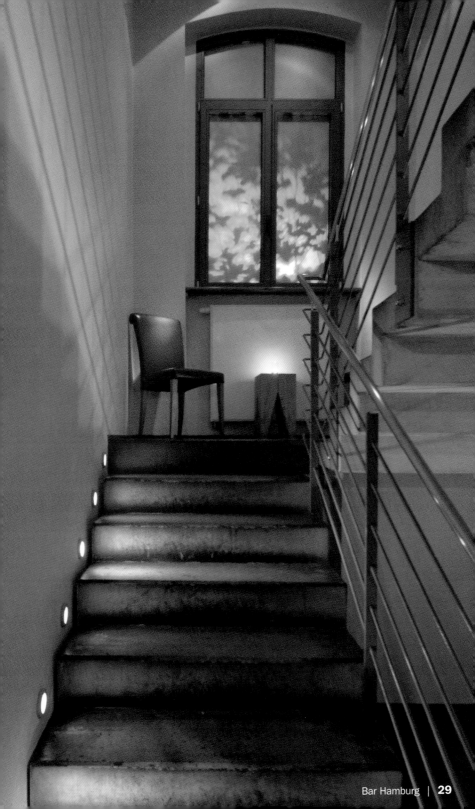

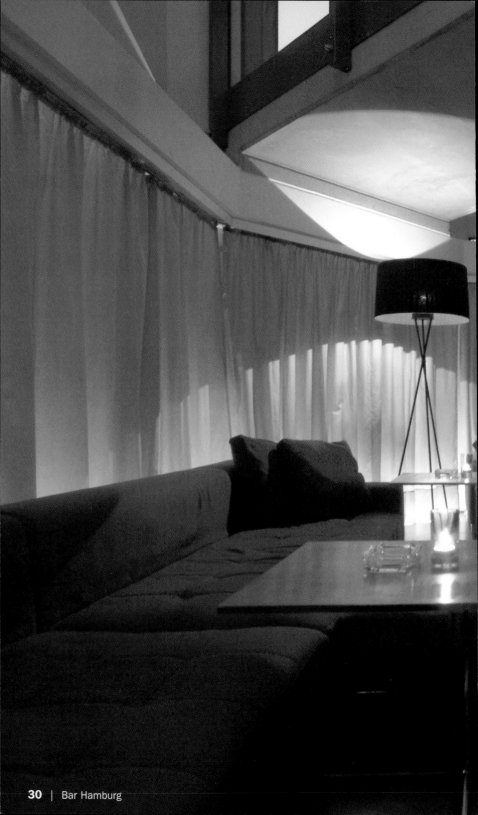

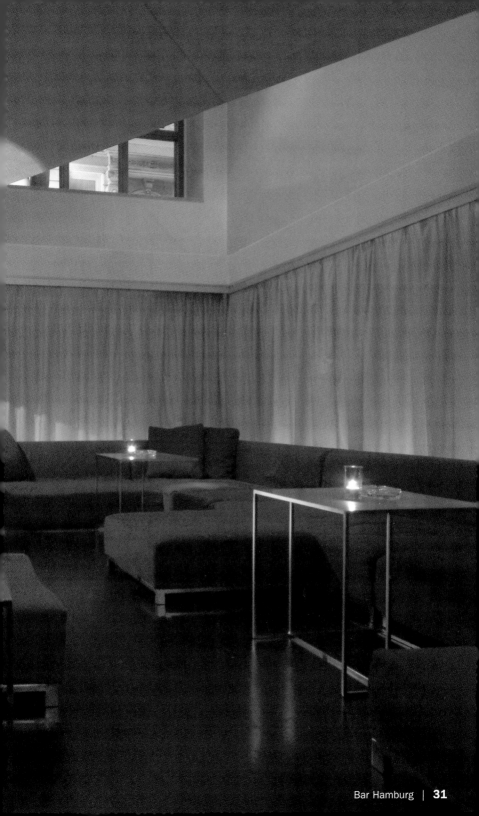

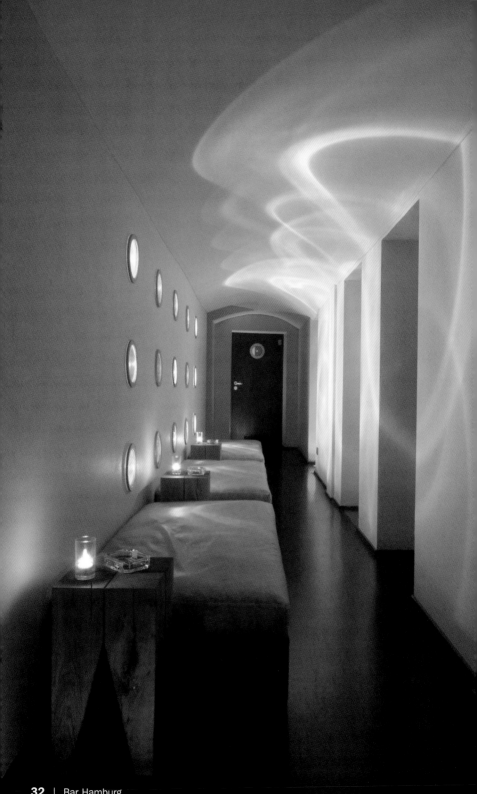

Julis Orchidee

(Spezialcocktail für Juli W. Biesterfeld)

cl Gin
cl Crème de Cassis (Johannisbeerlikör)
cl Zitronensaft
cl Kokosmilch
cl Passionsfruchtsaft
cl Ananassaft

Alle Zutaten in einen Shaker mit Eis geben und kräftig schütteln. Ein Longdrinkglas mit Eiswürfeln füllen und den Cocktail aus dem Shaker in das Glas gießen. Mit einem Ananasachtel und einer Cocktailkirsche garnieren.

Juli's Orchid

(special cocktail for Juli W. Biesterfeld)

cl gin
cl Crème de Cassis (redcurrant liqueur)
cl lemon juice
cl coconut milk
cl passionfruit juice
cl pineapple juice

Combine all ingredients in a shaker with ice. Shake well. Fill a longdrinkglass with icecubes and pour the cocktail in the glass. Garnish with a piece of pineapple and a cocktail cherry.

L'orchidée de Juli

(Cocktail spécial pour Juli W. Biesterfeld)

4 cl de gin
2 cl de Crème de Cassis
1 cl de jus de citron
2 cl de lait de coco
3 cl de jus de fruit de la passion
3 cl de jus d'ananas

Mettre tous les ingrédients dans un shaker et secouer vigoureusement. Remplir un verre à cocktail de glaçons et verser le cocktail du shaker dans le verre. Garnir avec un huitième d'ananas et une cerise cocktail.

Orquídea de Juli

(Cóctel especial para Juli W. Biesterfeld)

4 cl de ginebra
2 cl de Crème de Cassis (licor de casis)
1 cl de zumo de limón
2 cl de leche de coco
3 cl de zumo de granadilla
3 cl de zumo de piña

Poner todos los ingredientes con hielo en una coctelera y agitar fuertemente. Llenar un vaso de cóctel con cubos de hielo y verter en el vaso la mezcla de la coctelera. Adornar con un octavo de piña y una cereza de cóctel.

L'orchidea di Juli

(Cocktail speciale per Juli W. Biesterfeld)

4 cl di Gin
2 cl di crema di Cassis (liquore di ribes)
1 cl di succo di limone
2 cl di latte di cocco
3 cl di succo di frutto della passione
3 cl di succo di ananas

Versare tutti gli ingredienti con il ghiaccio in uno shaker e scuotere energicamente. Riempire un bicchiere da Longdrinks con cubetti di ghiaccio e versarvi il cocktail. Guarnire con un ottavo di ananas e una ciliegia da cocktail.

Bar Rossi

Design: Werner Haupt

Max-Brauer-Allee 279 | 22769 Schanzenviertel
Phone: +49 40 43 25 46 39
www.bar-rossi.net | info@inteldrink.de
Subway: Sternschanze
Opening hours: Every day 6 pm to 3 am, weekend 6 pm to 4 am
Average price: Cocktails € 7

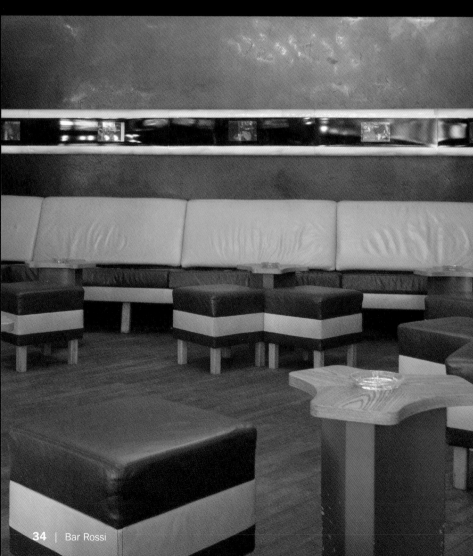

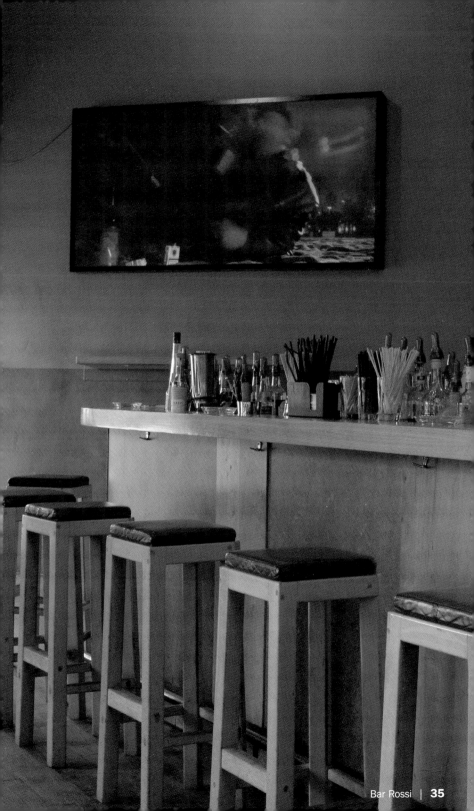

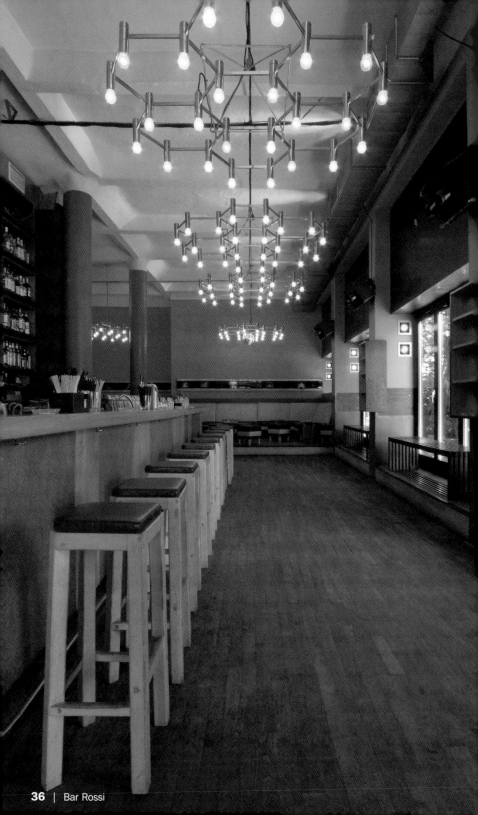

Frühstücks-Martini

5 cl Wodka
1 TL Orangenmarmelade
Orangenzesten als Dekoration

Zutaten in einen Shaker mit Eiswürfeln geben,
kräftig schütteln und in ein gekühltes Martiniglas
abseihen. Mit Orangenzesten garnieren.

Breakfast-Martini

5 cl vodka
1 tsp orange marmelade
Orange peels for decoration

Combine ingredients in a shaker with ice, mix
well, and pour into a chilled martini glass.
Decorate with orange peels.

Martini du petit déjeuner

5 cl de vodka
1 c. à café de marmelade d'orange
Zestes d'orange pour décorer

Mettre les ingrédients dans un shaker avec des
glaçons, secouer vigoureusement et verser dans
un verre à Martini froid. Garnir avec les zestes
d'orange.

Martini – desayuno

5 cl de vodka
1 cucharadita de mermelada de naranja
Cascaritas de naranjas para decoración

Poner los ingredientes con cubos de hielo en una
coctelera, agitar fuertemente y colar en un vaso
de Martini refrigerado. Adornar con cascaritas de
naranjas.

Colazione Martini

5 cl di vodka
1 cucchiaino di marmellata d'arancia
Scorza d'arancia per guarnire

Mettere gli ingredienti con ghiaccio in uno shaker,
scuotere energicamente e versare in un bicchiere
da Martini ghiacciato. Guarnire con scorza d'a-
rancia.

Bereuther

Design: Just Blue Design | Chef: Helmut Gesit

Klosterallee 100 | 20144 Eppendorf
Phone: +49 40 41 40 67 89
www.bereuther.de | info@bereuther.de
Subway: Eppendorfer Baum
Opening hours: Mon–Sat 7 pm to open end
Average price: € 15
Cuisine: Asian, European

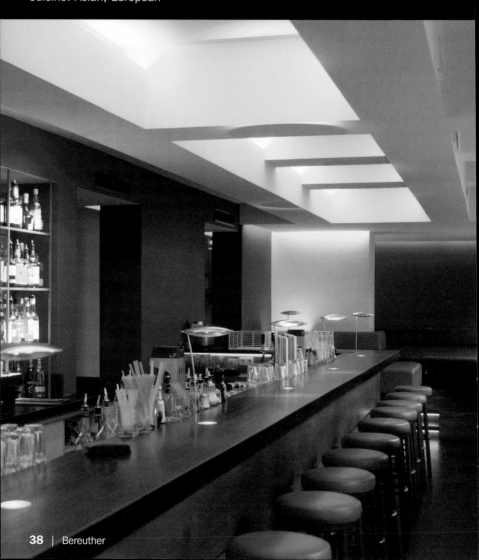

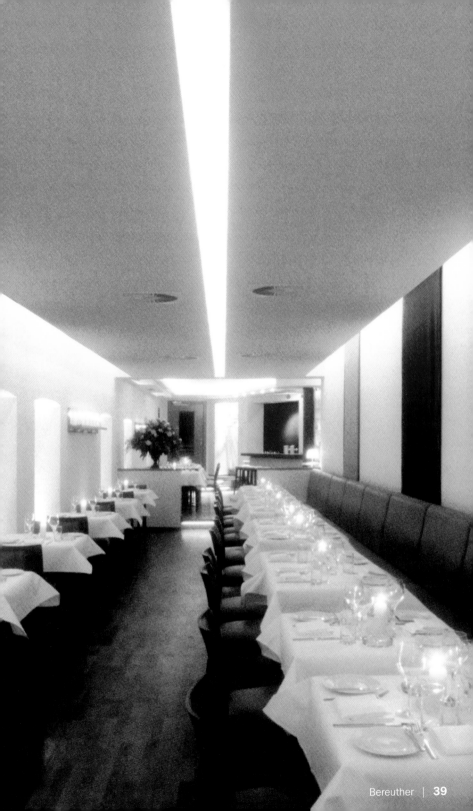

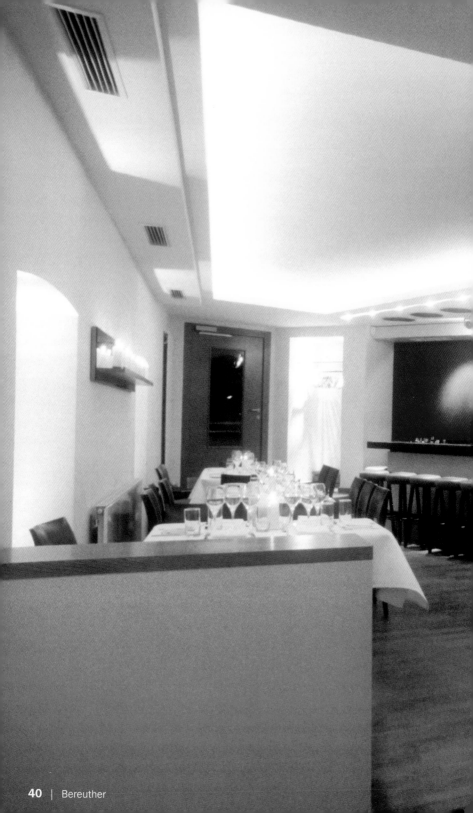

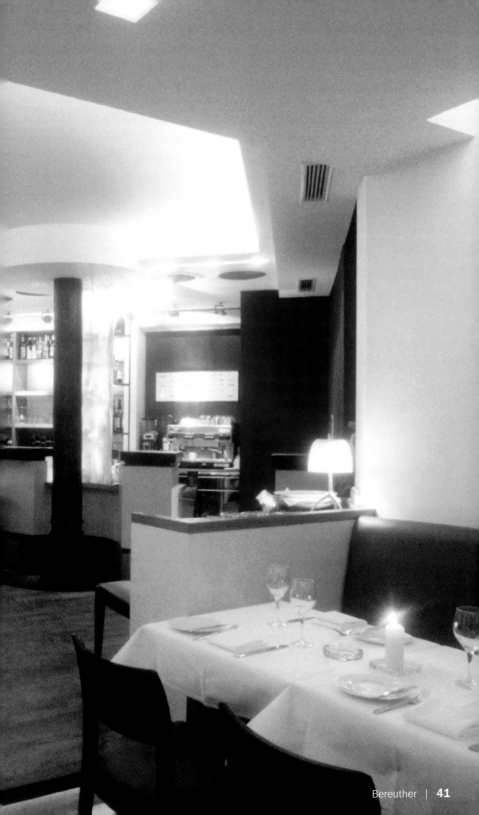

Brook

Design: Droppelmann, Ratke | Chef: Lars Schablinski

Bei den Mühren 98 | 20457 Altstadt
Phone: +49 40 37 50 31 28
www.restaurant-brook.de
Subway: Steinstraße, Meßberg, Rödingsmarkt
Opening hours: Mon–Sat 12 noon to 3 pm, 6 pm to 11 pm
Menu price: € 10–29
Cuisine: Haute Cuisine

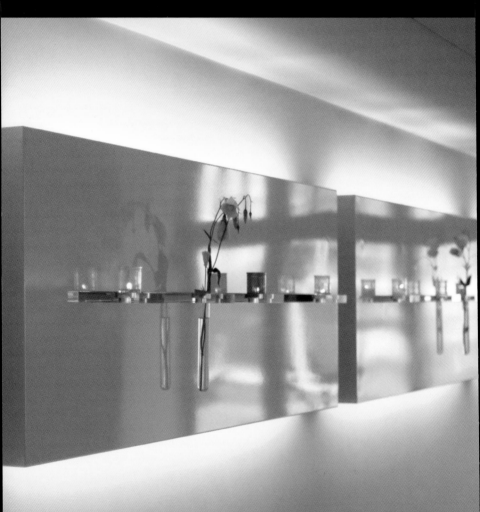

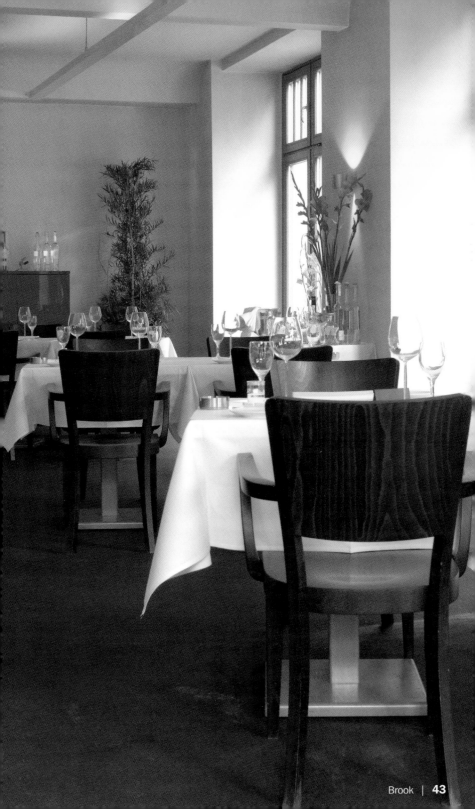

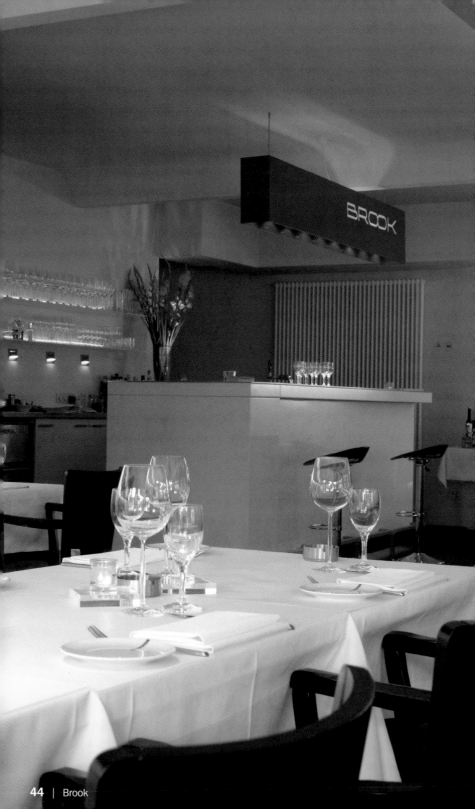

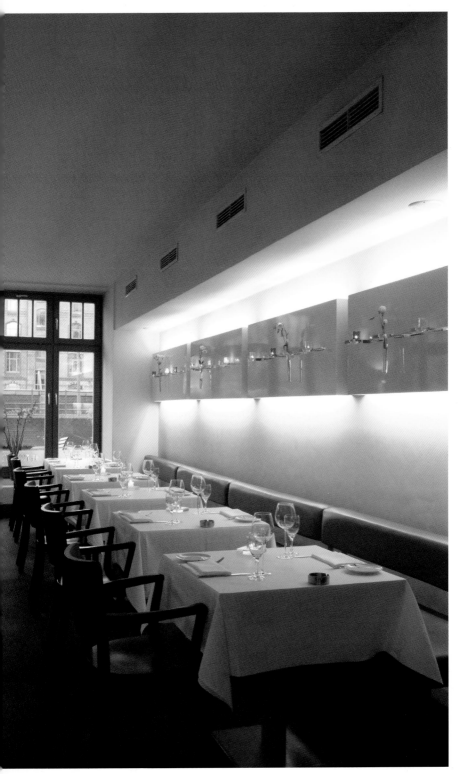

China Lounge

Design: Paul Heinen

Nobistor 14 / Reeperbahn | 22767 St.Pauli
Phone: +49 40 31 97 66 22
www.china-lounge.de | team@china-lounge.de
Subway: Reeperbahn
Opening hours: Thu 9 pm to open end, Fri and Sat 11 pm to open end
Average price: Longdrinks € 8
Cuisine: Dim Sum

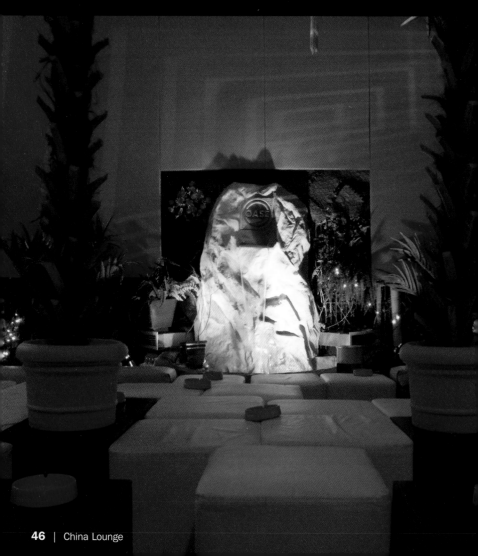

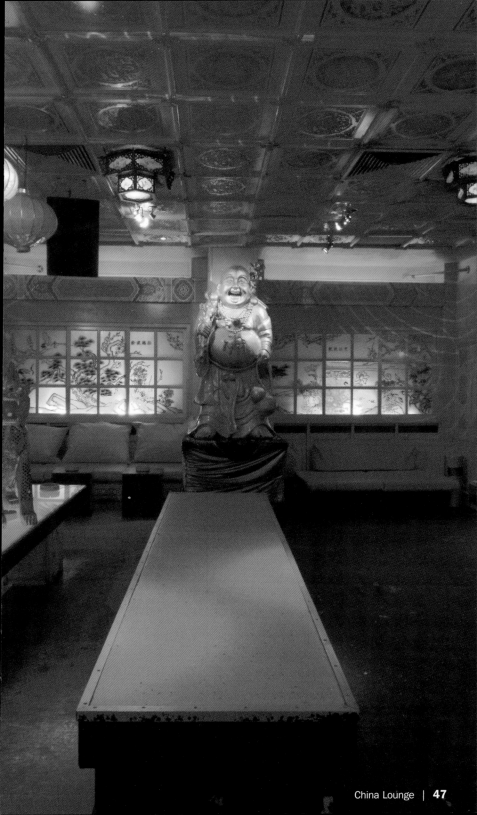

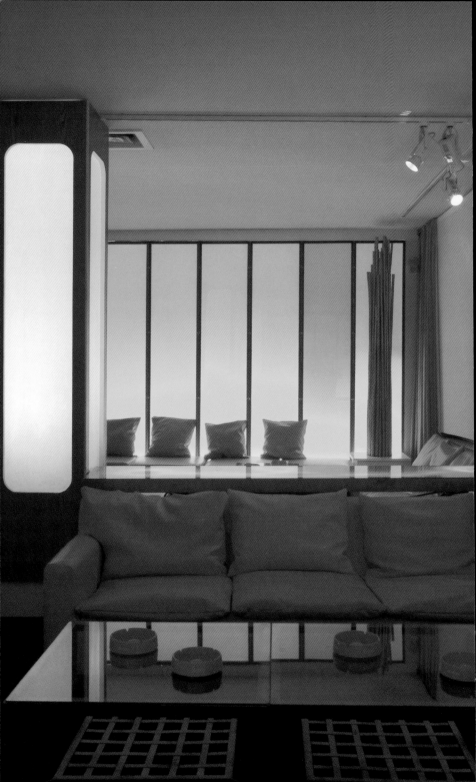

Sommer-Traum

cl Wodka
cl Kalhua (Kaffeelikör)
cl Galliano (italienischer Kräuterlikör)
00 ml Orangensaft
cl Grenadine
ür die Dekoration: Melonenschnitze, Cocktail-
rschen, Zitronenschnitze, Sternfrucht, Physalis,
trohhalm

le Zutaten, außer der Grenadine, in einen
haker mit Eis geben und gut schütteln. In ein mit
swürfeln gefülltes Glas abseihen und über einen
trohhalm die Grenadine unten in das Glas laufen
ssen. Mit den Früchten und dem Strohhalm gar-
eren.

hina Summer Dream

cl vodka
cl Kalhua (coffee liqueur)
cl Galliano (Italian herbal liqueur)
00 ml orange juice
cl grenadine
ecoration: Melonslices, cocktail cherries, lemon
ices, starfruit, physalis, straw

ombine all ingredients, except grenadine, in a
haker with ice. Shake well. Pour cocktail in a
ocktail glass with fresh ice cubes. Pour the gre-
adine through a straw in the bottom of the glass.
arnish with fruits and a straw.

Rêve d'été chinois

2 cl de vodka
2 cl de Kalhua
2 cl de Galliano
200 ml de jus d'orange
1 cl de grenadine
Décoration : Petits morceaux de melon, 2 cerises
cocktail, citron en tranches, carambole, physalis,
paille

Mettre tous les ingrédients à l'exception de la gre-
nadine dans un shaker avec des glaçons et bien
secouer. Verser dans un verre rempli de glaçons
et faire couler la grenadine dans le bas du verre
au moyen d'une paille. Garnir avec fruit et paille.

ueño de verano en China

cl de vodka
cl de Kalhua
cl de Galliano
00 ml de zumo de naranja
cl de granadina
ecoración: Melon rebanado, cerezas de cóctel,
món rebanado, carambola, fisalis, pasita

oner todos los ingredientes con hielo en una
octelera, excepto la granadina, y agitar bien.
olar en un vaso lleno con cubos de hielo y relle-
ar con la granadina haciéndola pasar hasta el
ondo del vaso por una pajita. Decorar con fruta y
asita.

Sogno d'estate cinese

2 cl di vodka
2 cl di kalhua
2 cl di galliano
200 ml di succo d'arancia
1 cl di grenadine
Guarnizione: Fette di melone, 2 ciliege da cock-
tail, fette di limone, carambola, physalis, can-
nuccia

Mettere tutti gli ingredienti, eccetto la Grenadine,
in uno shaker con ghiaccio e scuotere energica-
mente. Filtrare il tutto in un bicchiere riempito di
cubetti di ghiaccio e mediante una cannuccia far
scorrere la Grenadine sul fondo del bicchiere.
Guarnire con frutta e cannuccia.

Design: Lena Bardenhewer, Herbert Menzel
Chef: Holger Dankenbring

Lange Reihe 68 / Greifswalder Str. 43 | 20099 St. Georg
Phone: +49 40 24 94 22
www.restaurant-cox.de | info@restaurant-cox.de
Subway: Hauptbahnhof
Opening hours: Mon–Fri 12 noon to 3 pm, Mon–Sun 7 pm to 11:30 pm
Menu price: Lunch € 5–11, Dinner € 7–19.50
Cuisine: New European

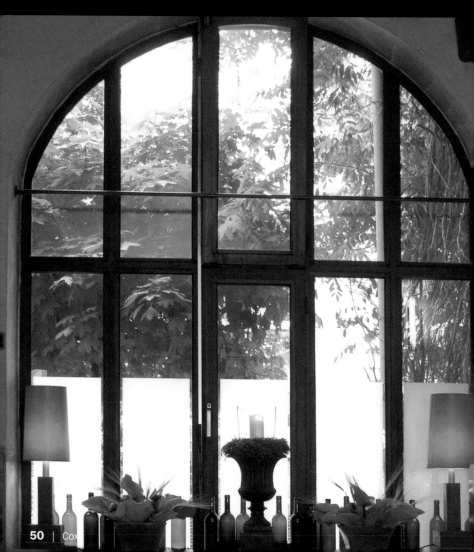

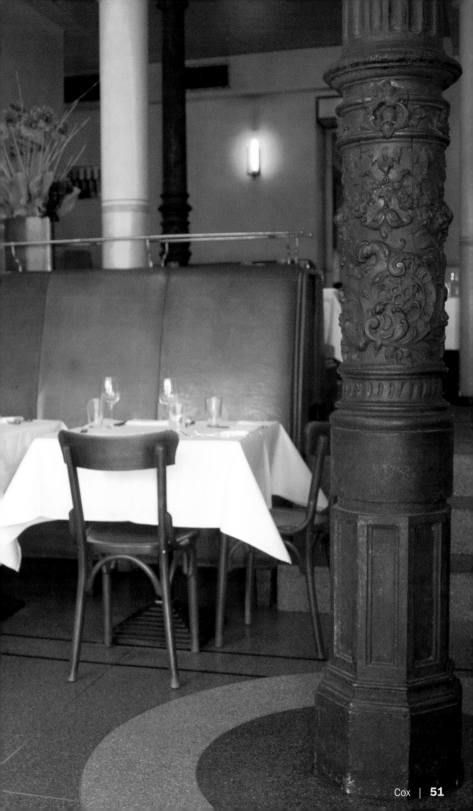

Da Caio Ristorante & Bar

Design: Regine Schwedhelm, Sybille von Heyden
Chef: Renzo Ferrario

Beim alten Gaswerk 3 | 22761 Bahrenfeld
Phone: +49 40 89 06 24 68
www.dacaio-restaurant.de | da_caio@gastwerk-hotel.de
Subway: Bahrenfeld
Opening hours: Mon–Fri 12 noon to 3 pm, Mon–Sat 6 pm to 11 pm,
closed on Sundays
Average price: € 18
Cuisine: Italian

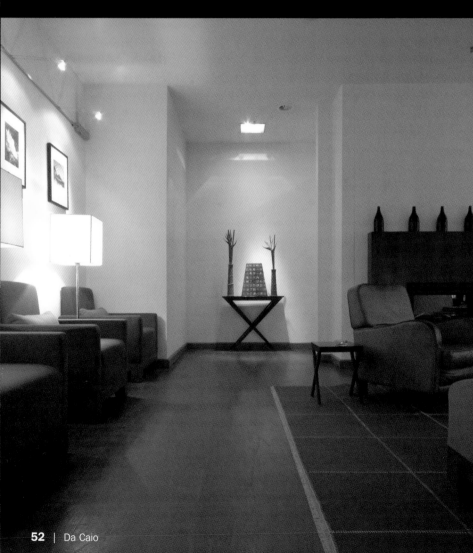

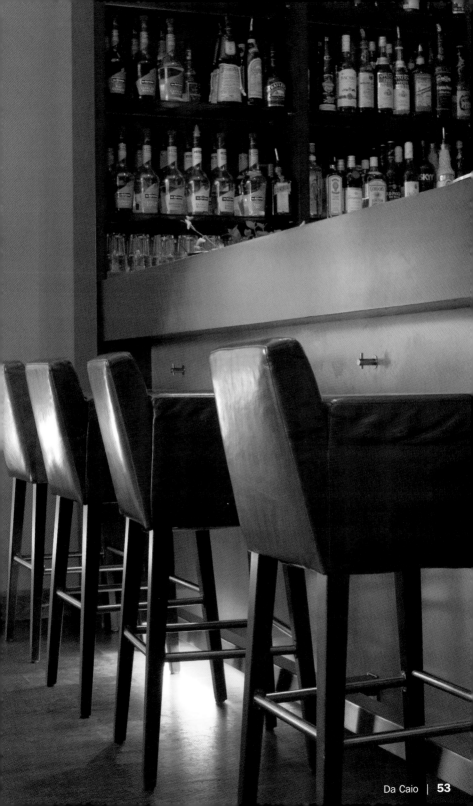

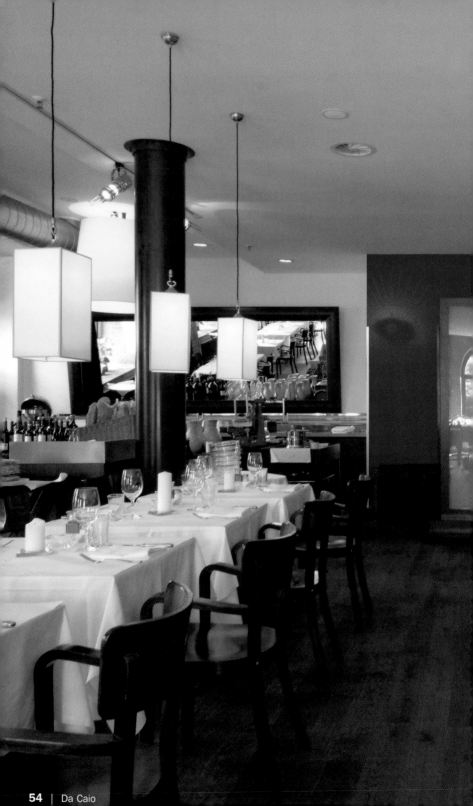

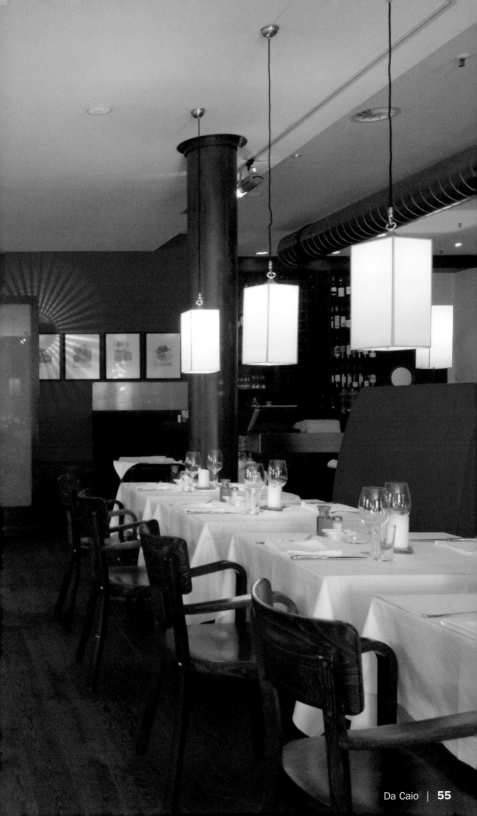

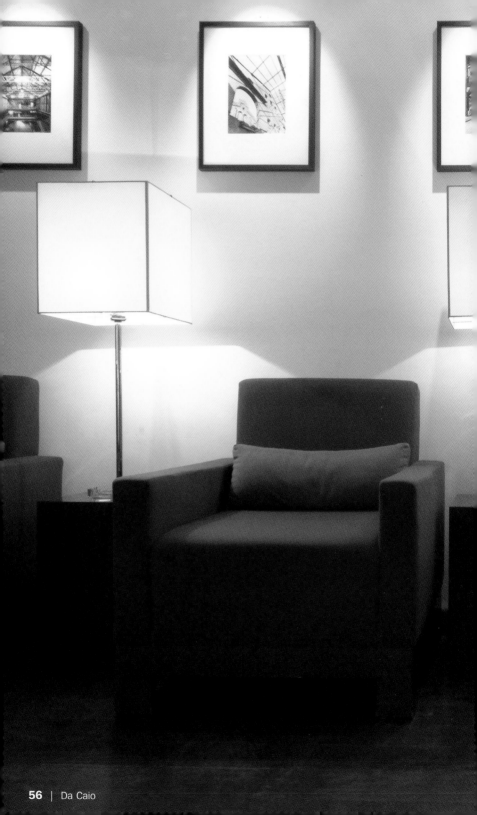

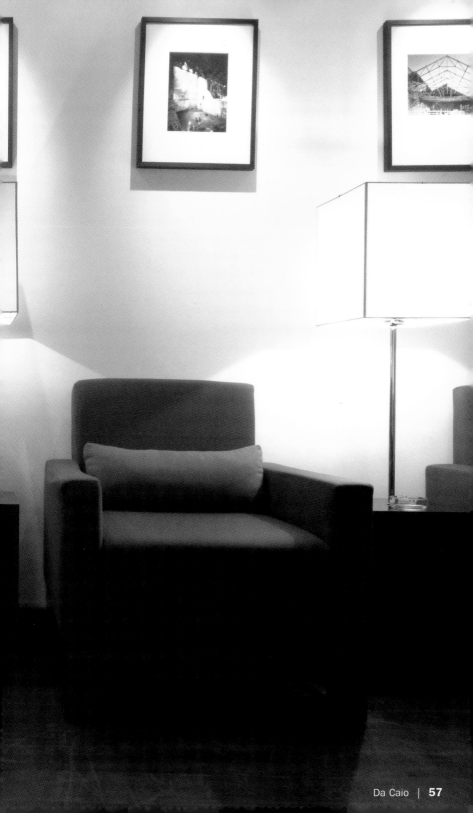

Grüne
Spargelspitzen
auf Ziegenkäsebärlauchmousse

Green Asparagus Tips with Goatcheese-
Bear's Garlic-Mousse

Pointes d'asperges vertes sur mousse de
fromage de chèvre à l'ail des ours

Puntas de espárragos verdes sobre mousse
de ajo silvestre y queso de cabra

Punte di asparagi verdi su mousse di
formaggio caprino e aglio orsino

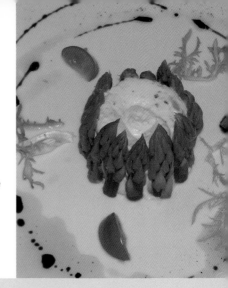

50 grüne Spargelspitzen, ca. 5 cm, gegart
50 g Ziegenfrischkäse (z.B. Picandou)
100 g Ricotta
1 Bund Bärlauch
Salz, Pfeffer
Balsamicoessig
Olivenöl
Kirschtomaten
Kresse oder Salat zum Garnieren

Den Ziegenfrischkäse mit dem Ricotta und dei
gehackten Bärlauch verrühren, mit Salz ur
Pfeffer abschmecken. Die Mousse kreisförmig
die Mitte des Tellers spritzen und d
Spargelspitzen hochkant in die Mousse drücke.
Mit Essig, Öl, Tomatenecken und Salatblättche
garnieren.

50 green asparagustips, about 2 in., cooked
2 oz fresh goatcheese (e.g. Picandou)
3 oz ricotta
1 bunch bear's garlic
Salt, pepper
Olive oil
Balsamic vinegar
Cherry tomatoes
Cress or salad to garnish

Cobine goatcheese, ricotta and chopped bear
garlic in a bowl and stir until smooth. Season wi
salt and pepper. Put mousse in a circular shap
on the plate and place asperagus vertical in l
Garnish with vinegar, olive oil, sliced cherry tom
toes and salad.

0 pointes d'asperges vertes cuites d'env. 5 cm
0 g de fromage de chèvre frais (par ex. du
icandou)
.00 g de ricotta
 botte d'ail des ours
el, poivre
inaigre balsamique
uile d'olive
omates cerises
resson ou salade pour la garniture

Mélanger le fromage de chèvre frais avec la ricotta et l'ail des ours haché, assaisonner avec du sel et du poivre. Poser la mousse en rond au milieu de l'assiette et enfoncer les pointes d'asperges verticalement dans la mousse. Garnir avec du vinaigre, de l'huile, des morceaux de tomates et de la salade.

0 puntas de espárragos verdes, aprox. 5 cm,
ocidas
0 g de queso fresco de cabra (p. ej. Picandou)
.00 g de ricotta
. manojo de ajo silvestre
al, pimienta
inagre balsámico
ceite de oliva
omates cherry
erro o lechuga para decorar

Mezclar el queso fresco de cabra con la ricotta y el ajo silvestre picado, sazonar con sal y pimienta. Salpicar el mousse en forma circular en el centro del plato y presionar las puntas de espárragos de canto en el mousse. Decorar con vinagre, aceite, tomates cortados en punta y lechuga.

0 punte di asparagi di circa 5 cm cotte
0 g di formaggio caprino fresco (per es.
icandou)
00 g di ricotta
 mazzetto di aglio orsino
ale, pepe
ceto balsamico
lio d'oliva
omodorini
gretto o insalata per guarnire

Mescolare il formaggio caprino con la ricotta e l'aglio orsino, insaporire con sale e pepe. Spruzzare la mousse in forma circolare nel mezzo del piatto e mettere di taglio le punte di asparagi nella mousse. Guarnire con aceto, olio, pomodori tagliati in quattro e insalata.

Das weiße Haus

Chef: Tim Mälzer

Neumühlen 50 / Museumshafen | 22763 Altona-Ottensen
Phone: +49 40 3 90 90 16
www.das-weisse-haus.de | info@das-weisse-haus.de
Subway: Altona
Opening hours: Mon–Sat 12 noon to 3 pm, 6 pm to 10:30 pm,
Sun 10 am to 5 pm, closed on Tuesdays
Menu price: € 27–35
Cuisine: Fusion cocking, New German style

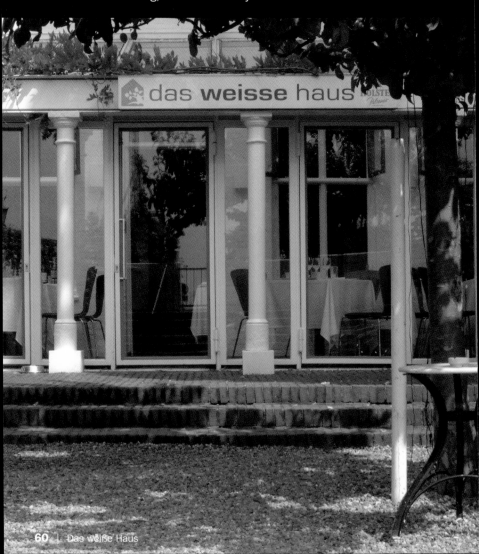

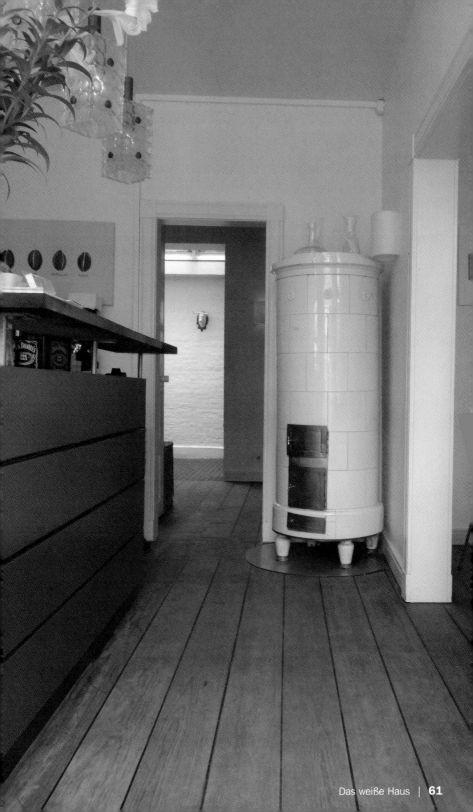

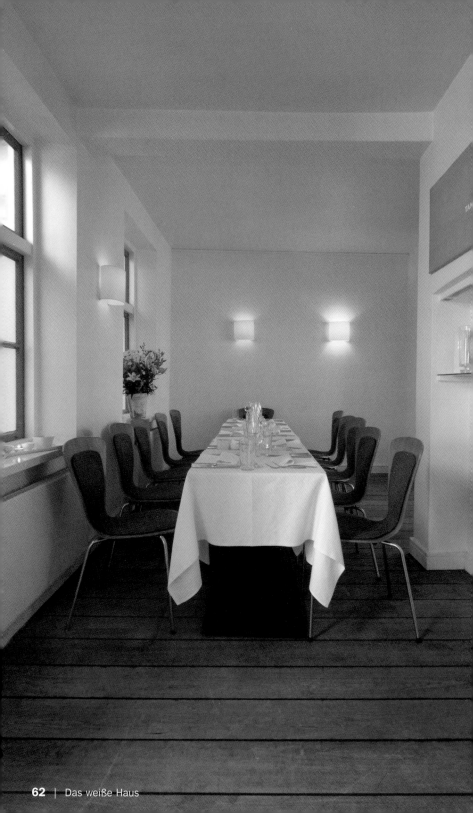

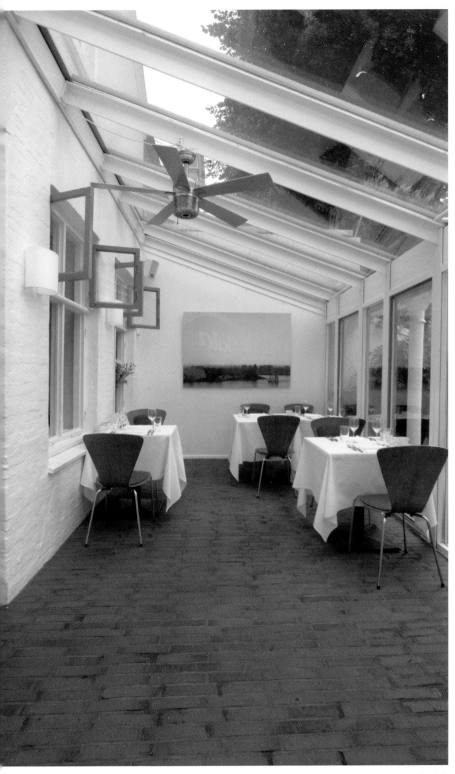

Die Welt ist schön

Design: Charles de Picciotto

Neuer Pferdemarkt 4 | 20359 St. Pauli
Phone: +40 40 18 78 88
www.dieweltistschoen.net | mail@dieweltistschoen.net
Subway: Feldstraße
Opening hours: Every day 8 pm to open end
Average price: Cocktails € 6.50

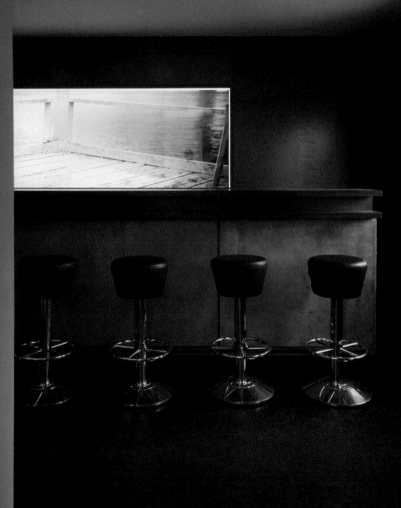

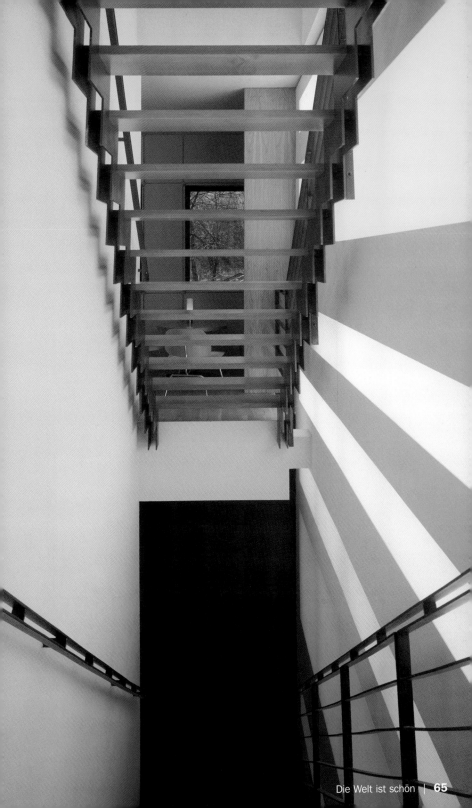

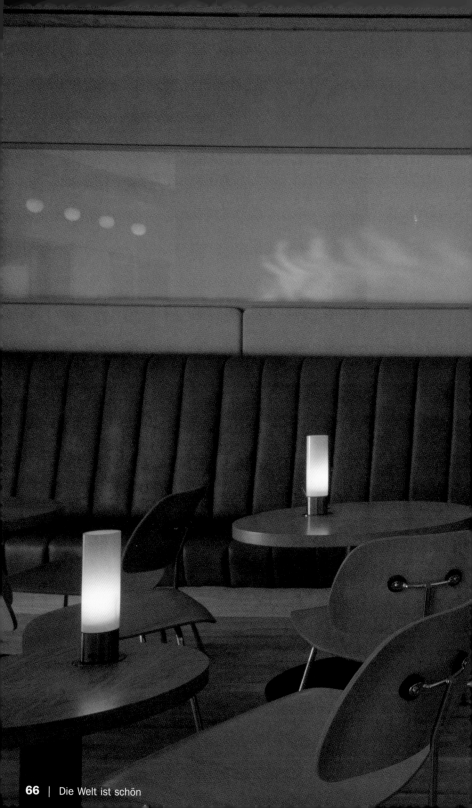

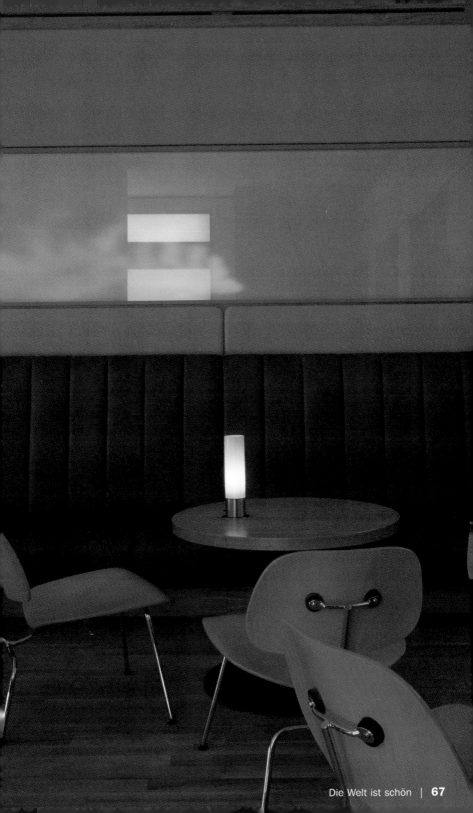

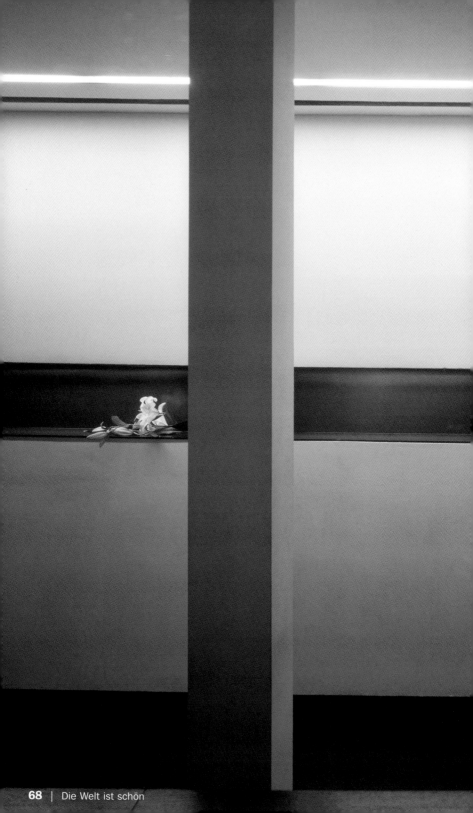

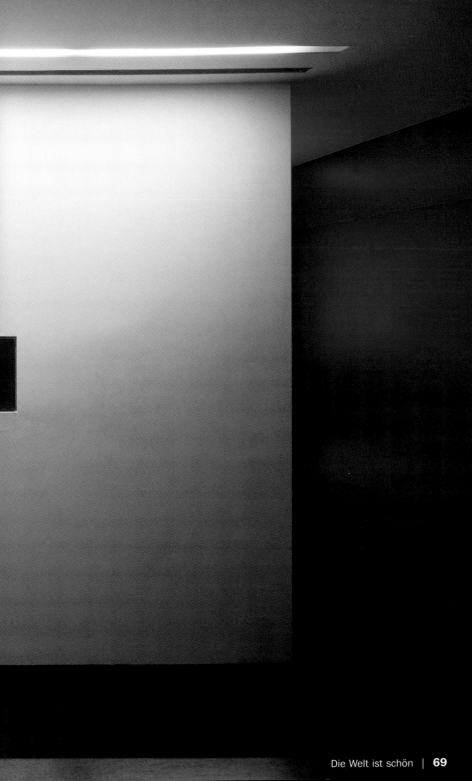

Doc Cheng's

Design: Miguel Cancio Martins | Chef: Niels Mester

Neuer Jungfernstieg 9-14 | 20255 Innenstadt
Phone: +49 40 3 49 43 33
www.raffles-hvj.de | emailus.hvj@raffles.com
Subway: Jungfernstieg, Gänsemarkt
Opening hours: Tue–Fri 12 noon to 2:30 pm, Tue–Thu 6 pm to 11 pm,
Fri–Sat 6 pm to 12:30 am, Sun 6 pm to 11 pm, closed on Monday
Cuisine: Asian, European

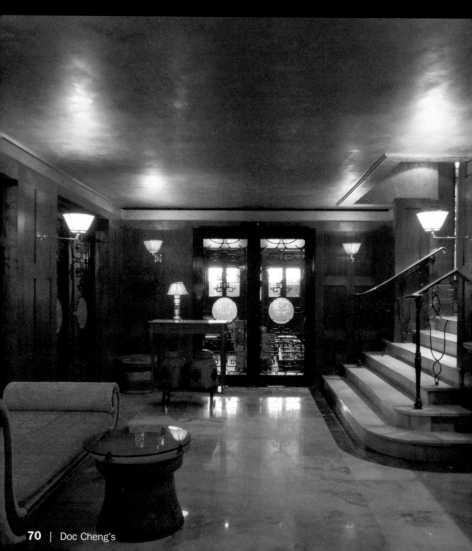

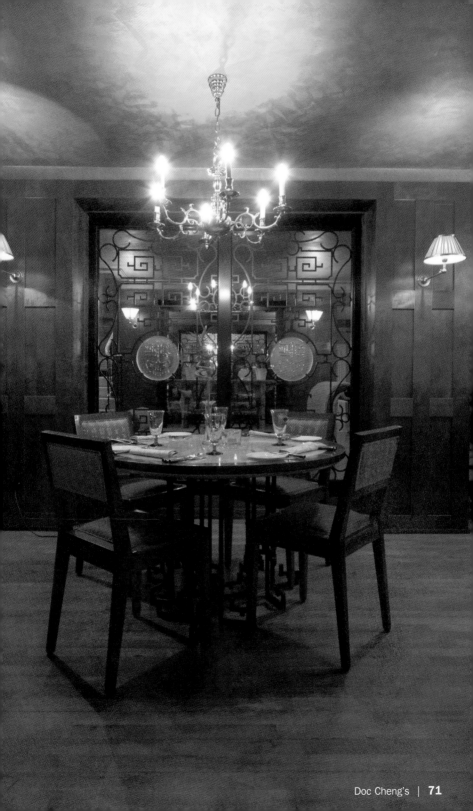

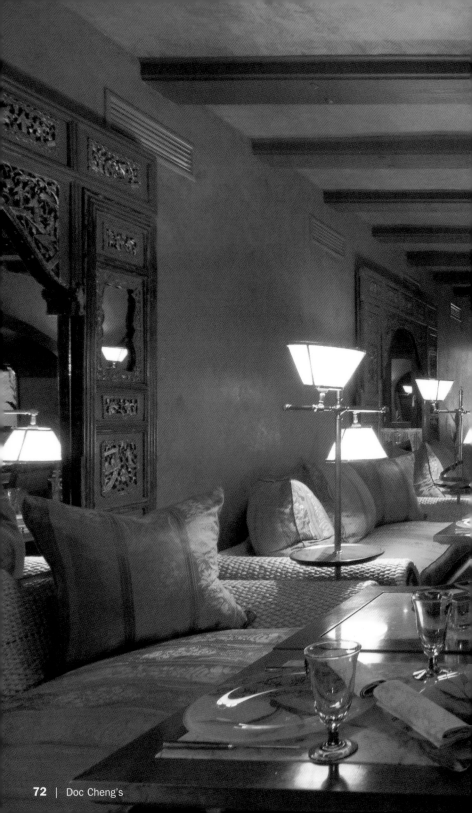

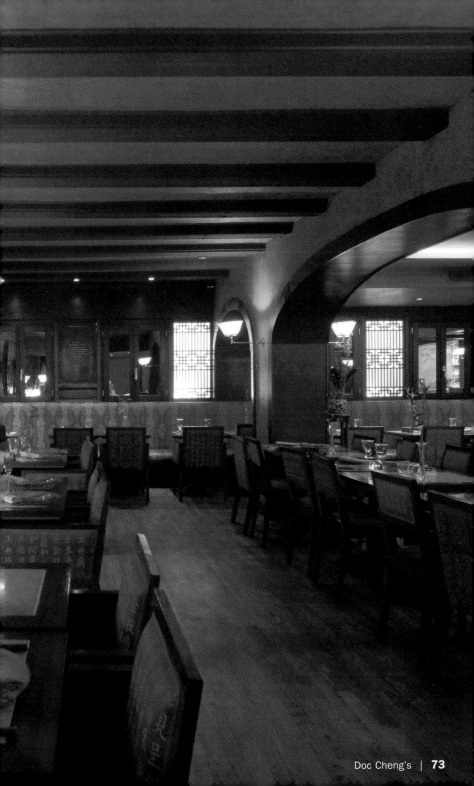

Eisenstein

Design: Medium | Chef: Jes Autzen

Friedensallee 9 | 22765 Altona-Ottensen
Phone: +49 40 3 90 46 06
www.restaurant-eisenstein.de | restaurant-eisenstein@restaurant-eisenstein.de
Subway: Altona
Opening hours: Mon–Sat 11 am to 1 am, Sun 10 am to 1 am
Menu price: Lunch € 9, Dinner € 15
Cuisine: Modern

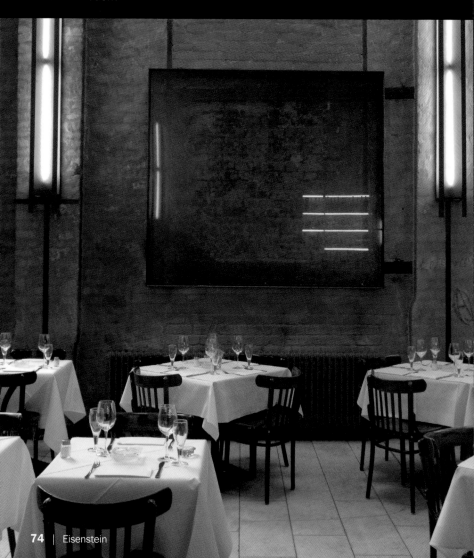

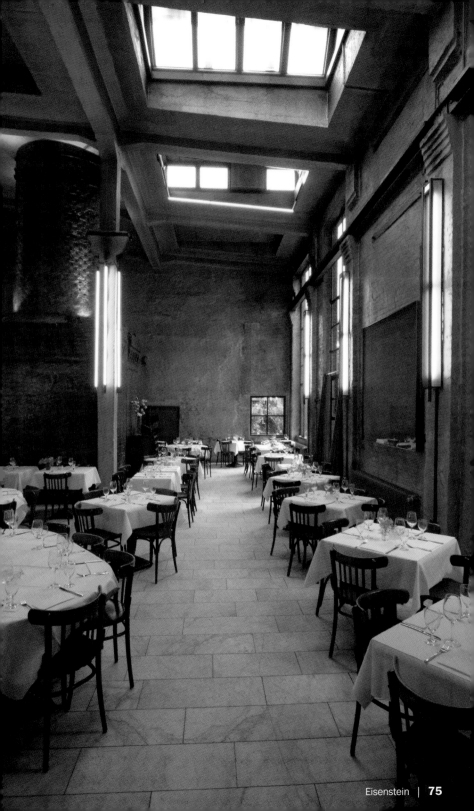

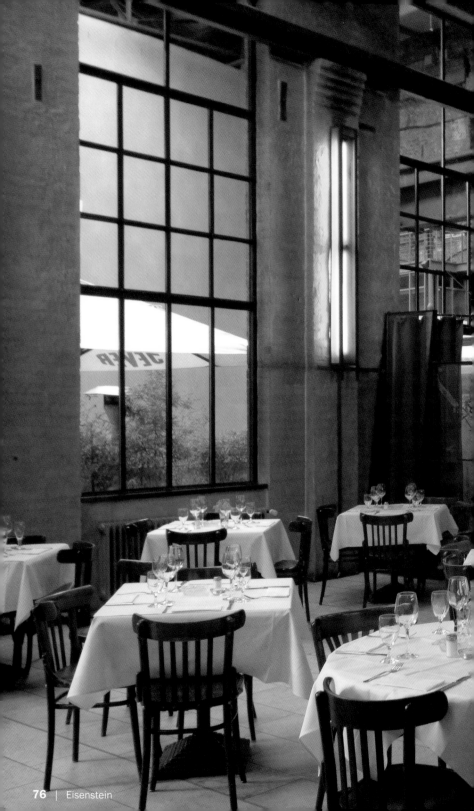

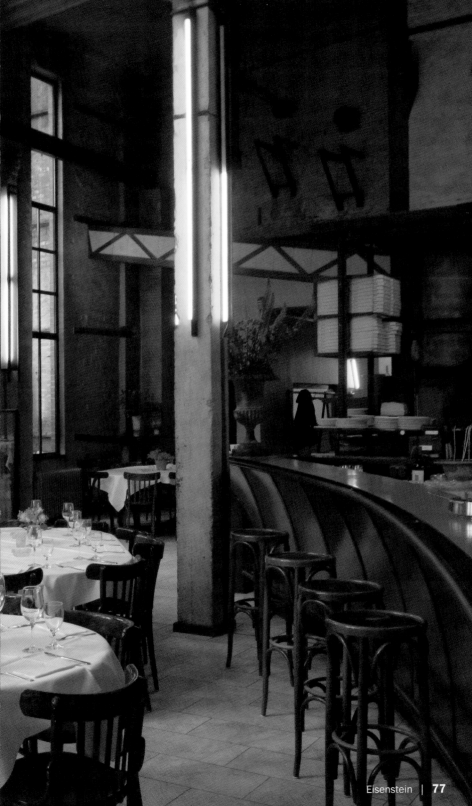

Saltimbocca von der Wachtel

mit zweierlei Paprikapüree und Balsamicojus

Saltimbocca of Quail with two Kinds of Bell Pepper Puree and Balsamic Jus

Saltimbocca de caille aux deux purées de poivron et jus de vinaigre balsamique

Saltimbocca de codorniz con dos clases de puré de pimientos y jugo balsámico

Saltimbocca di quaglia in due modi, con purè di peperoni e succo balsamico

6 Wachteln
24 Salbeiblätter
6 Scheiben Parmaschinken
12 Zahnstocher
Olivenöl
1 Karotte, gewürfelt
1 kleine Sellerieknolle, gewürfelt
100 ml Rotwein
500 g mehlige Kartoffeln
2 rote und 2 gelbe Paprika
4 Schalotten
2 Knoblauchzehen
Salz, Pfeffer
Zitronensaft
50 ml Balsamicoessig

Bruststücke und Keulen der Wachteln auslösen, das Brustfleisch würzen, mit Salbei und einer halben Scheibe Parmaschinken umwickeln, mit Zahnstochern feststecken.

Die zerkleinerten Keulen und Knochen in Öl anbraten, Karotte und Sellerie dazugeben, mit Rotwein ablöschen, mit Wasser auffüllen und zu Jus einkochen lassen.
Kartoffeln weichkochen und durch die Presse drücken. Paprika schälen, würfeln und gelbe und rote Paprika getrennt jeweils mit Schalotten, Knoblauch, Salz, Pfeffer, Zitronensaft weich dünsten. In der Zwischenzeit das Brustfleisch kurz anbraten und bei 170 °C ca. fünf bis sechs Minuten braten. Nun Paprikas pürieren und abschmecken. Gelben und roten Paprikabrei jeweils mit Kartoffelbrei mischen und warmstellen. Jus durch ein Sieb gießen und mit Balsamicoessig verfeinern.
Zweierlei Paprikapüree als Nocken auf den Teller setzen, die Wachtelbruststücke darauflegen und Balsamicojus darüber geben.

6 quails
24 leaves of sage
6 slices of parma ham
12 toothpicks
Olive oil
1 carrot, diced
1 small celery, diced
100 ml red wine
1 lb 1 1/2 oz mealy potatoes
2 red and 2 yellow bell peppers
4 shallots
2 cloves garlic
Salt, pepper
Lemon juice
50 ml Balsamic vinegar

Draw breasts and legs of the quails, season breasts, wrap sage and half a slice of parma ham around each one and use a toothpick to fasten.

Fry legs and rest of the bones in a pot, add cut up carrot and celery and red wine, fill up with water and reduce to a jus by simmering.
Cook potatoes until done and squeeze through potatoe press. Peel bell peppers, chop and cook the red and yellow separately with shallots, garlic, salt, pepper and lemon juice until soft and mix in a blender. In the meantime fry breasts in olive oil and cook in a 340 °F oven for about five or six minutes. Mix mashed potatoes with red and yellow bell pepper puree separately. Keep warm. Strain jus and add balsamic vinegar.
Spoon bell pepper puree on plates, put breast on top and pour balsamic jus around them.

5 cailles
24 feuilles de sauge
5 tranches de jambon de Parme
12 cure-dents
Huile d'olive
1 carotte, coupèe en dès
1 petit céleri, coupèe en dès
100 ml de vin rouge
500 g de pommes de terre farineuses
2 poivrons rouges et 2 poivrons jaunes
4 échalotes
2 gousses d'ail
Sel, poivre
Jus de citron
50 ml de vinaigre balsamique

Découper les filets et les cuisses des cailles, assaisonner les filets, les entourer de sauge et d'une demi-tranchee de jambon de Parme, fixer avec des cure-dents.

Faire rissoler les cuisses coupes en morceaux et les os dans de l'huile, ajouter carotte et céleri, déglacer avec le vin rouge, rajouter de l'eau et faire cuire pour obtenir un jus.
Faire cuire les pommes de terre et les passer au presse-purée. Eplucher les poivrons, les découper en dés et faire cuire les poivrons rouges et jaunes séparément avec les échalotes, l'ail, du sel, du poivre, du jus de citron. Entre-temps, faire revenir les filets de cailles et les faire cuire env. cinq à six minutes à 170 °C. Transformer les poivrons jaunes et rouges en purée et les assaisonner. Mélanger la purée de poivron jaune et rouge séparément à la purée de pommes de terre et conserver au chaud. Passer le jus au tamis et l'affiner avec le vinaigre balsamique.
Poser de petites boulettes des deux purées de poivron dans l'assiette, déposer les filets de cailles dessus et arroser du jus au vinaigre balsamique.

5 codornices
24 hojas de salvia
5 lonchas de jamón de parma
12 mondadientes
Aceite de oliva
1 zanahoria, en cuadraditos
1 tubérculo pequeño de apio, en cuadraditos
100 ml de vino tinto
500 g de patatas harinosas
2 pimientos rojos y 2 amarillos
4 chalotes
2 dientes de ajo
Sal, pimienta
Zumo de limón
50 ml de vinagre balsámico

Separar las pechugas y los muslos de las codornices, sazonar las pechugas, envolverlas con salvia y media loncha de jamón de Parma, sujetarlas pinchándolas con los mondadientes.

Sofreír en aceite los muslos troceados y los huesos, añadir la zanahoria y el apio, rebajar todo con vino tinto, echar agua y espesarlo al fuego hasta que se forme una salsa.
Coser las patatas hasta que estén blandas y pasarlas por el pasapurés. Pelar los pimientos, cortarlos en cuadraditos y rehogar separadamente los pimientos amarillos y rojos hasta que estén blandos con los chalotes, los dientes de ajo, sal, pimienta, zumo de limón. Entretanto sofreír corto tiempo las pechugas de codorniz y asarlas durante aprox. cinco a seis minutos a 170 °C. Ahora hacer un puré con los pimientos y sazonarlos. Cada uno de los purés de pimientos mezclarlos con el puré de patatas y ponerlos a calentar. Pasar la salsa por un colador y refinar con vinagre balsámico.
Poner las dos clases de puré de pimientos como salientes sobre el plato, poner encima las pechugas de codorniz y verter sobre ellas el jugo balsámico.

5 quaglie
24 foglie di salvia
5 fette di prosciutto di Parma
12 stuzzicadenti
Olio d'oliva
1 carota, tagliata a cubetti
1 bulbo piccolo di sedano, tagliata a cubetti
100 ml di vino rosso
500 g di patate farinose
2 peperoni rossi e due gialli
4 scalogne
2 spicchi d'aglio
Sale, Pepe
Succo di limone
50 ml di aceto balsamico

Staccare i petti e i cosciotti dalle quaglie, insaporire i petti, arrotolarli in una mezza fetta di prosciutto di Parma e salvia e fissarli con stuzzicadenti.

Aggiungere i cosciotti tagliati a pezzetti e le ossa rosolati in olio, aggiungere carota e sedano, smorzare con vino rosso, riempire con acqua e fare addensare fino ad ottenere un sugo.
Cuocere le patate e passarle al pressapatate.
Sbucciare i peperoni, tagliarli a cubetti e cuocere i gialli separatamente dai rossi, ognuno con scalogno, aglio, sale, pepe e succo di limone. Nel frattempo rosolare brevemente a fuoco vivo i petti di quaglia, quindi arrostirli a 170 °C per cinque o sei minuti. Ridurre ora i peperoni in purea ed insaporirli con sale e pepe. Mescolare la purea di peperoni gialli e rossi ognuno con la purea di patate e tenere al caldo. Colare il brodo ed ingentilirlo con aceto balsamico.
Mettere nel piatto i due tipi di purea di peperoni a mo' di cupola, posarvi i petti di quaglia e versarvi il sugo all'aceto balsamico.

Henssler & Henssler

Design: Udo Strack | Chef: Steffen Henssler, Werner Henssler

Große Elbstraße 160 | 22767 Altona
Phone: +49 40 38 69 90 00
www.h2dine.de | info@h2dine.de
Subway: Königsstraße
Opening hours: Every day 12 noon to 3 pm, 6 pm to 11:30 pm
Menu price: € 8.50–16.50
Cuisine: Japanese, Californian

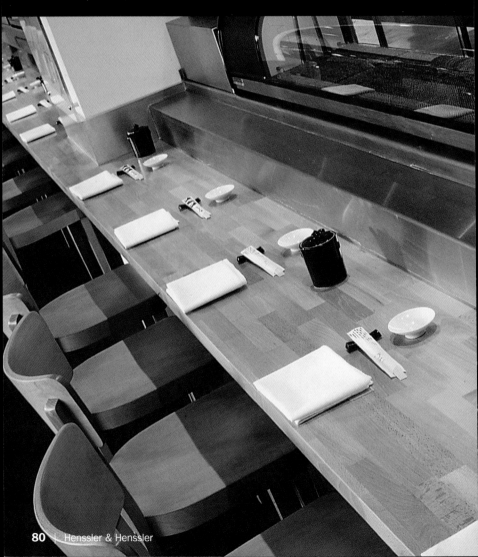

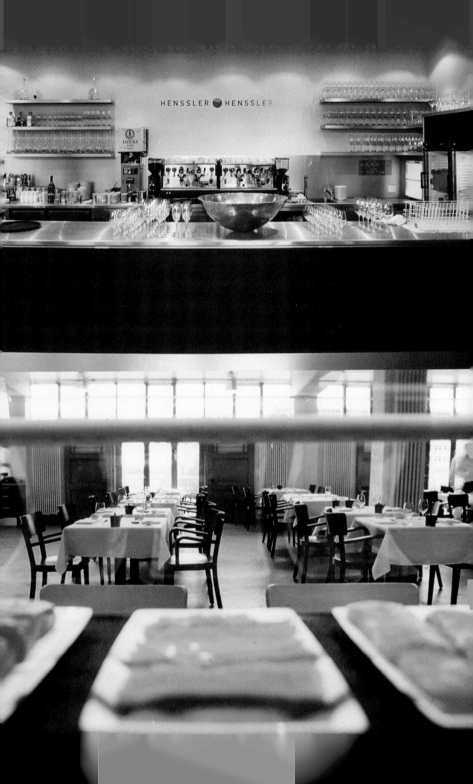

IndoChine

Design: Michael Ma | Chef: Johann Tang, Sven Langanke

Neumühlen 11 | 22763 Altona-Ottensen
Phone: +49 40 39 80 78 80
www.indochine.de | info@indochine.de
Subway: Altona
Opening hours: Every day 12 noon to 12 midnight
Average price: € 18.50
Cuisine: Vietnamese, Cambodian, Laos cuisine, Colonial-French

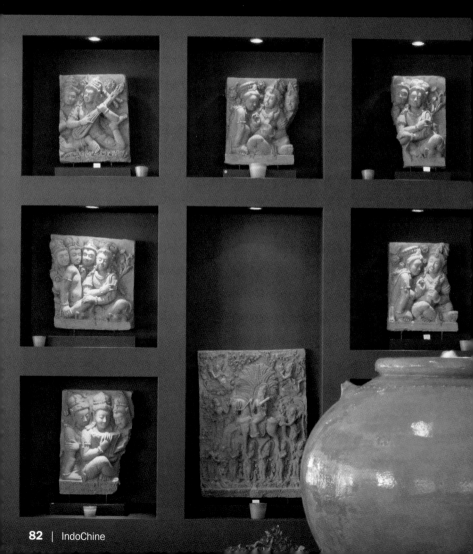

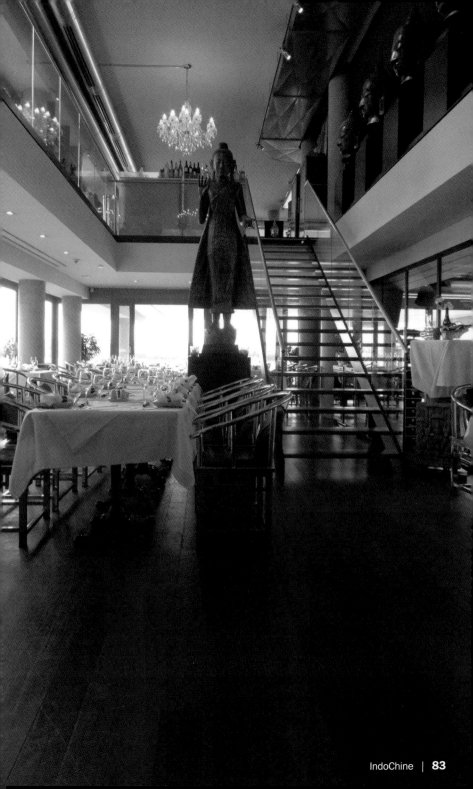

Le Ciel Restaurant et Bar

Chef: Stéphane de Miéville

An der Alster 52-56 | 20099 St. Georg
Phone: +49 40 21 00 10 70
www.leciel.de | restaurantleciel.hamburg@lemeridien.com
Subway: Hauptbahnhof
Opening hours: Every day Breakfast 6:30 am to 10:30 am,
Lunch 12 noon to 2:30 pm, Dinner 6 pm to 11 pm
Menu price: Lunch € 22.00, Dinner € 49.50
Cuisine: International

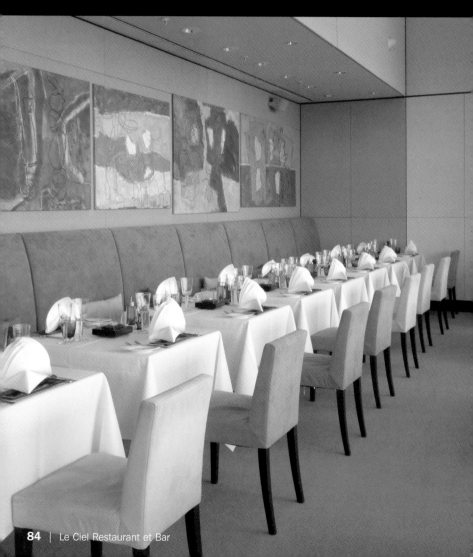

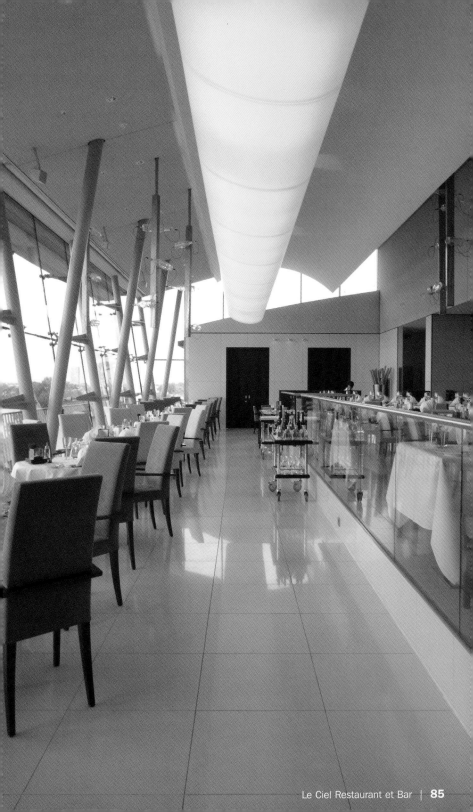

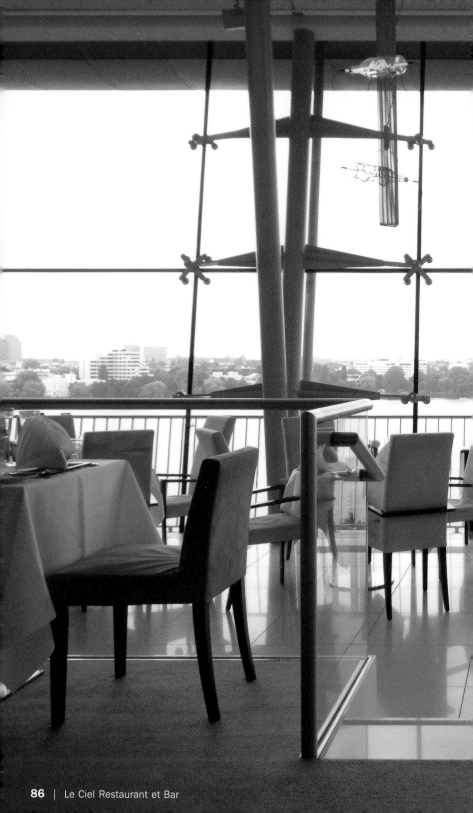

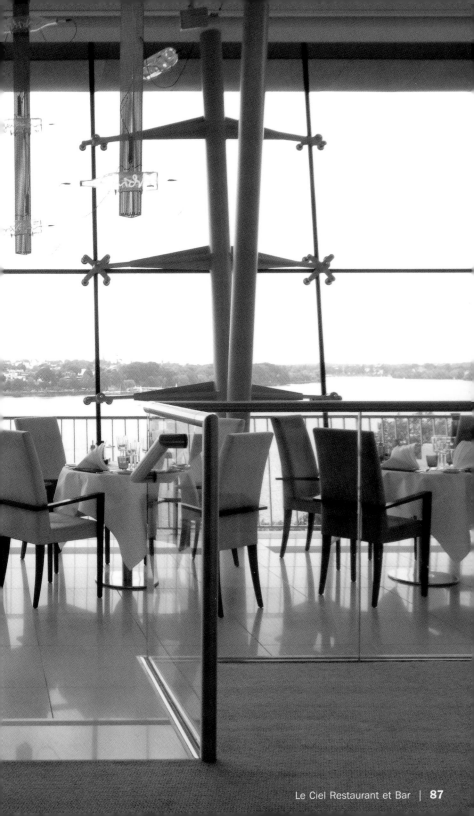

Nil

Design: Rüdiger Mahlau
Chef: Jochen Armbruster, Matthias Schulz

Neuer Pferdemarkt 5 | 20359 St. Pauli
Phone: +49 40 4 39 78 23
www.restaurant-nil.de | essen@restaurant-nil.de
Subway: Feldstraße
Opening hours: Mon–Thu 6 pm to 11 pm, Fri and Sat 6 pm to 12 midnight,
Sun 6 pm to 10 pm, closed on Tuesdays
Menu price: € 20–32
Cuisine: Modern European

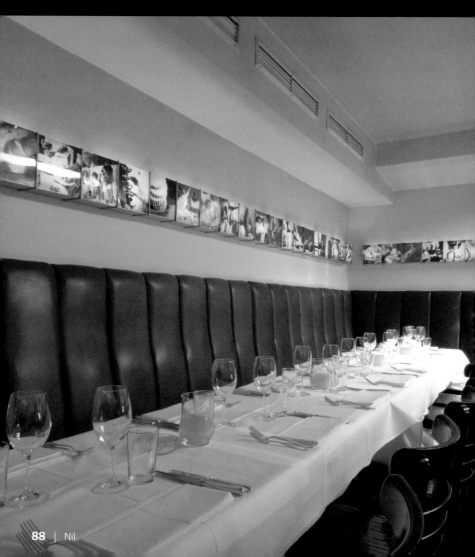

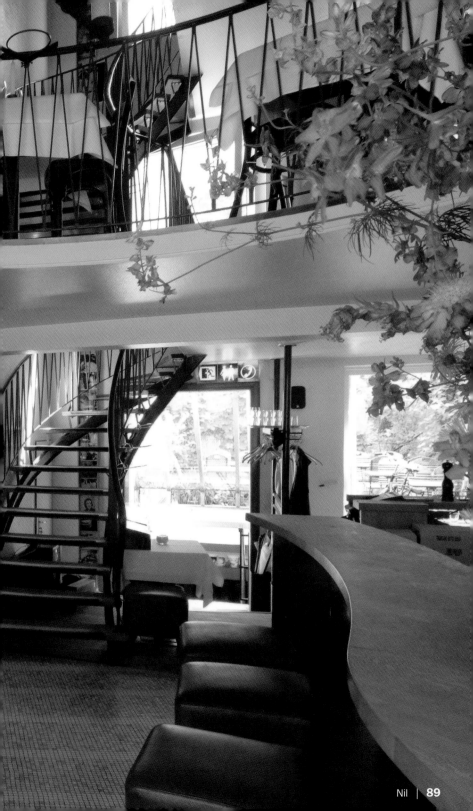

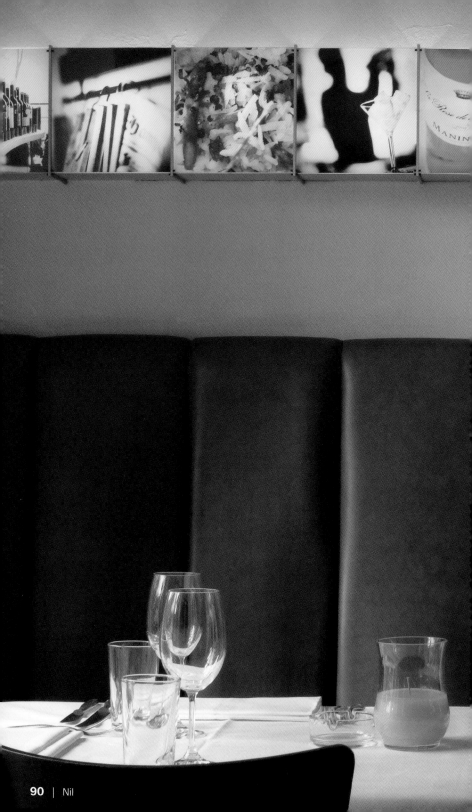

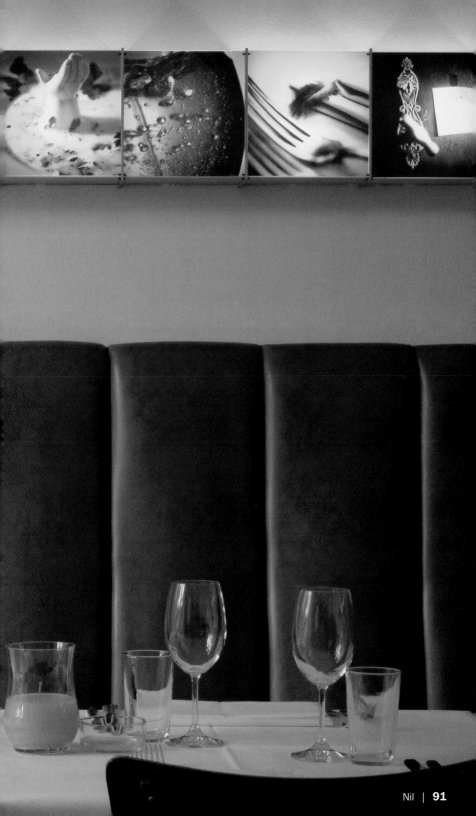

Saliba

Design: Carmen Muñoz de Franck | Chef: Bouchaib Laghchioua

Leverkusenstraße 54 | 22761 Bahrenfeld
Phone: +49 40 85 80 71
www.saliba.de | info@saliba.de
Subway: Diebsteich
Opening hours: Mon–Sat 6 pm to 11 pm
Menu price: € 17–22, € 43–46
Cuisine: Finest Syrian cuisine

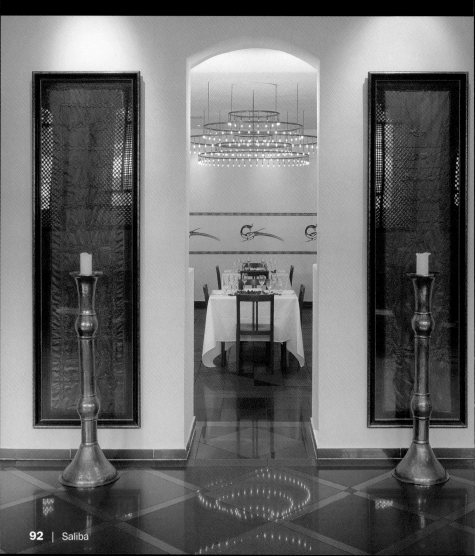

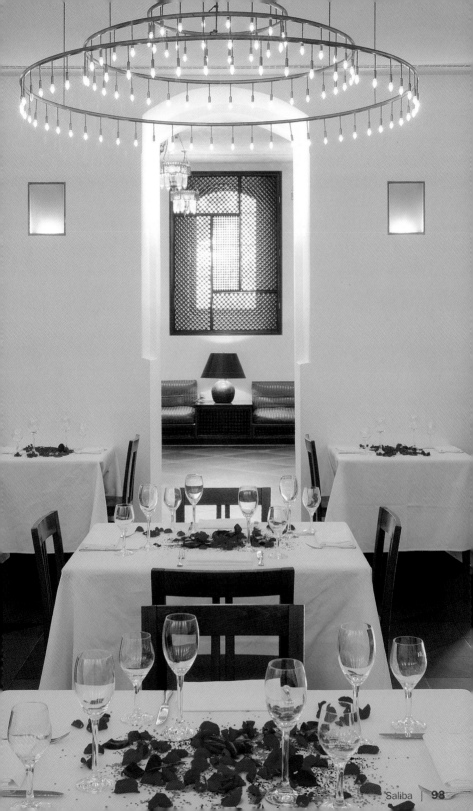

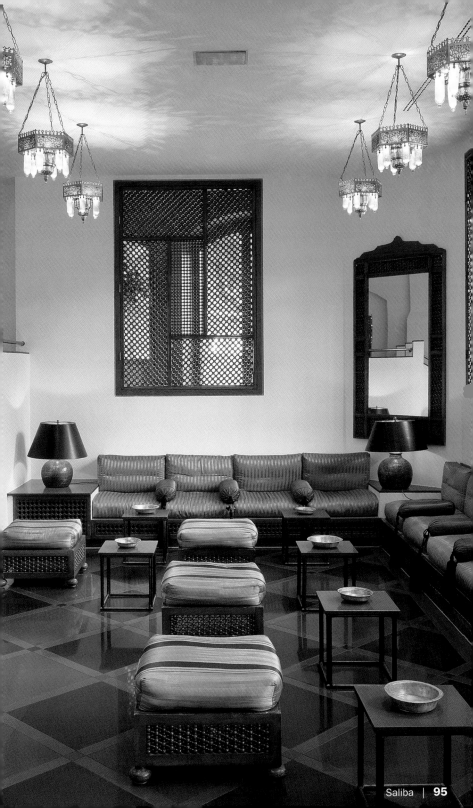

Auberginen mit Schafskäse

Egg Plants with Sheep Cheese
Aubergines au fromage de brebis
Berenjenas con queso de oveja
Melanzane con formaggio di pecora

3 große Auberginen
Salz
Pflanzenöl zum Frittieren
100 g glatte Petersilie
200 g Schafskäse
1 EL Harrissa (eine Gewürzpaste, die in Orient-
und Delikatessläden erhältlich ist)
1 EL Tomatenmark
Saft einer halben Zitrone
1 EL Olivenöl

Auberginen in ein Zentimeter breite Streife
schneiden und für 30 Minuten in Salzwass
legen, abgießen und trocken tupfen. In Öl b
180 °C hellbraun ausbacken, auf Küchenpapi
abtropfen und abkühlen lassen, dann auf ein
Platte ausbreiten. Petersilie in Streifen schneide
und darüberstreuen, Schafskäse in ein Zent
meter große Würfel schneiden und in die Mit
der Auberginen häufen. Restliche Zutaten m
wenig Salz verrühren und nur über den Käs
gießen.

3 large egg plants
Salt
Oil for deep frying
3 1/2 oz parsley leaves
7 oz sheep cheese
1 tbsp Harissa (herb paste)
1 tbsp tomato paste
Juice of 1/2 a lemon
1 tbsp olive oil

Cut egg plants into 1/2 in. thick slices and put
salted water for 30 minutes, then dry off. Deep f
in hot oil (360 °F) until light brown, then dry off
paper towel, let cool and and spread on a plat
Cut parsley in stripes, sprinkle on egg plant, c
sheep cheese in cubes and place in middle of eg
plants. Combine last four ingredients, season wi
salt and pour only over sheep cheese.

3 grandes aubergines
Sel
Huile végétale pour la friture
100 g de persil plat
200 g de fromage de brebis
1 c. à soupe d'harissa (pâte pimentée que l'on
trouve dans les magasins de produits orientaux
et épiceries fines)
1 c. à soupe de concentré de tomate
Le jus d'un demi-citron
1 c. à soupe d'huile d'olive

Couper les aubergines en tranches d'un centimètre de large et les faire tremper pendant 30 minutes dans de l'eau salée, les égoutter et les essuyer. Les faire frire dans l'huile à 180 °C jusqu'à ce qu'elles soient dorées, les égoutter sur du papier de cuisine et les laisser refroidir, les étaler ensuite sur une plaque. Couper le persil en lanières et le répartir sur les aubergines, couper le fromage de brebis en dés d'un centimètre et les poser en petits tas au milieu des aubergines. Mélanger les ingrédients restants avec un peu de sel et les verser simplement sur le fromage.

3 berenjenas grandes
Sal
Aceite vegetal para freír
100 g de perejil liso
200 g de queso de oveja
1 cucharadas de Harrissa (una pasta de condimentos, que se puede comprar en tiendas orientales y de exquisiteces)
1 cucharada de concentrado de tomate
Zumo de medio limón
1 cucharada de aceite de oliva

Cortar las berenjenas en tiras de un centímetro y ponerlas por 30 minutos en agua salada, verter el agua y secarlas. Freírlas a punto en el aceite a 180 °C, dejarlas escurrir y enfriar sobre papel de cocina, luego ponerlas extendidas sobre una bandeja. Cortar el perejil en tiritas y expancirlo encima, cortar el queso de oveja en cubitos de aprox. un centímetro y amontonarlo en el centro de las berenjenas. Mezclar el resto de los ingredientes con un poco de sal y luego verterlo sobre el queso.

3 melanzane grandi
Sale
Olio di semi per la frittura
100 g di prezzemolo piatto
200 g di formaggio di pecora
1 cucchiaio di Harrissa (una pasta di spezie, reperibile in paesi orientali e negozi specializzati)
1 cucchiaio di concentrato dio pomodoro
Succo di mezzo limone
1 cucchiaio di olio d'oliva

Tagliare le melanzane in strisce da un centimetro e metterli sotto acqua salata, scolarle ed asciugarle con carta da cucina. Friggere in olio a 180 °C fino a farle diventare di un colore marrone chiaro, sgocciolarle su carta da cucina e farle raffreddare, stenderle poi su una piastra. Tagliare il prezzemolo a strisce e spargerlo sulle melanzane, tagliare il formaggio di pecora in cubetti da un centimetro e ammucchiarlo nel mezzo delle melanzane. Mescolare il resto degli ingredienti aggiungendo poco sale e versare il tutto sul formaggio.

Sands

Design: KBNK Architekten | Chef: Truong Tuong, Uyen

Mittelweg 26 | 20148 Poseldorf
Phone: +49 40 45 44 44
sands-mittelweg@hamburg.de
Subway: Hallerstraße
Opening hours: Mon–Fri 12 noon to 3 pm, 6 pm to 12 midnight,
Sat–Sun 6 pm to open end
Cuisine: Asian, modern

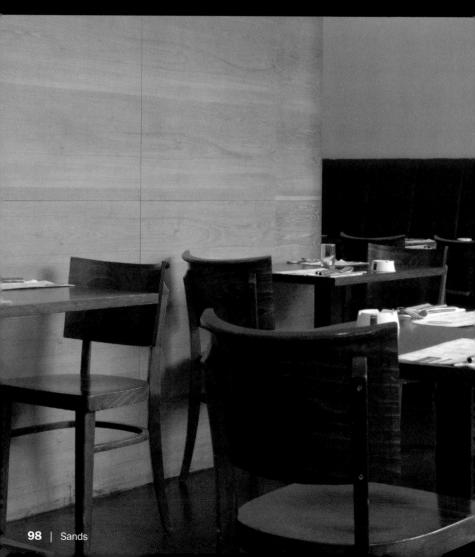

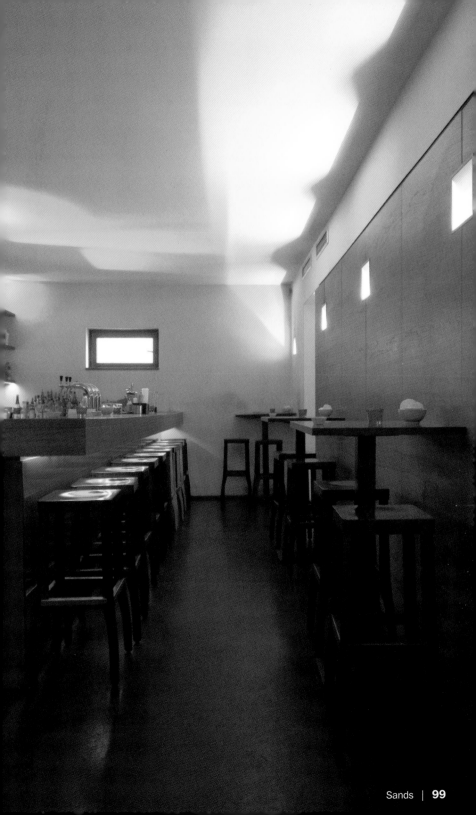

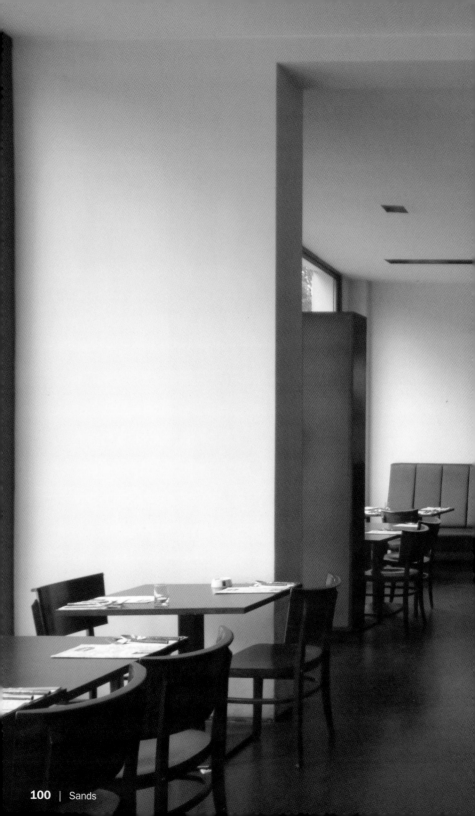

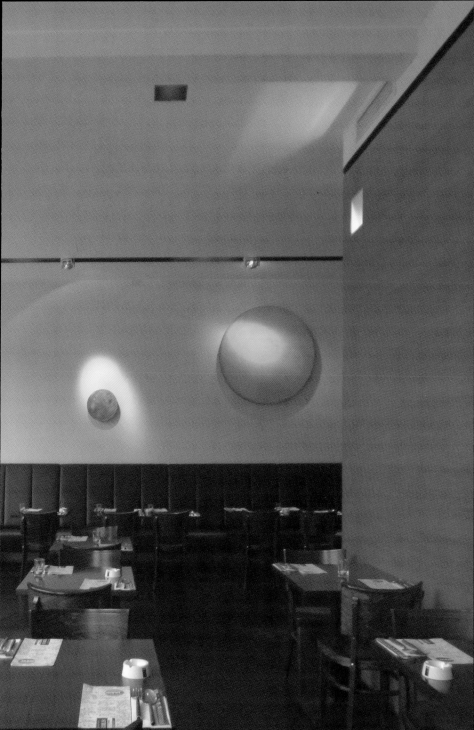

Ingwer-Zitronengras
Crème brûlée

Crème brûlée with Ginger and Lemon

Crème brûlée au gingembre et à la citronnelle

Crema brulee con pasto limón y jengibre

Crema brulee de zenzero e erba cedrata

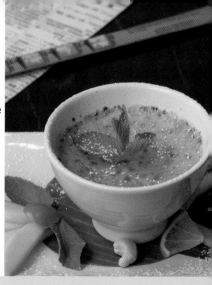

1 l Sahne
100 g Zucker
1 Vanilleschote, aufgeschlitzt
50 g Ingwer, gehackt
1 Stengel Zitronengras, gequetscht
8 Eigelb
2 EL brauner Zucker
2 EL Puderzucker
Bunsenbrenner zum Gratinieren
Früchte und Minze zum Dekorieren

Sahne, Zucker, Vanilleschote, Ingwer, Zitr
nengras aufkochen, fünf Minuten köcheln und
Minuten ziehen lassen.
Eigelbe verquirlen und die heiße, nicht me
kochende Flüssigkeit dazugeben. Durch ein Si
gießen. In ofenfeste Formen geben und
Wasserbad bei 120 °C ca. 45 Minuten im Of
pochieren.
Ganz auskühlen lassen (nicht im Kühlschran
mit braunem Zucker und Puderzucker bestreu
und gratinieren. Mit Früchten und Minze dekor
ren.

1 l cream
3 1/2 oz sugar
1 vanilla beam, slited
1 3/4 oz ginger, chopped
1 piece of lemongras, chopped
8 egg yolks
2 tbsp brown sugar
2 tbsp powder sugar
Bunsen burner to gratinee
Fruits and mint leaves for decoration

Bring cream, sugar, vanilla beam, ginger, lemo
gras to a boil, let simmer for five minutes and s
aside (30 minutes).
Whisk egg yolks and mix with hot, but not boilin
cream. Put through a strainer. Pour in fireproofe
molds and put in a water bath in a 250 °F ov
for 45 minutes.
Let cool completely (not in fridge). Sprinkle top
cold crème with sugar and powder sugar. U
bunsen burner to give top a light brown col
Decorate with fruits and mint leaves.

l de crème
00 g de sucre
gousse de vanille ouverte
0 g de gingembre haché
branche de citronnelle écrasée
jaunes d'œufs
c. à soupe de sucre brun
c. à soupe de sucre en poudre
ec Bunsen pour gratiner
uits et menthe pour la décoration

Faire cuire la crème, le sucre, la gousse de vanille, le gingembre, la citronnelle, laisser cuire à feux doux pendant cinq minutes et laisser mijoter pendant 30 minutes.
Battre les jaunes d'œufs et ajouter le liquide chaud mais plus bouillonnant. Tamiser. Verser dans des moules allant au four et faire pocher au bain-marie pendant env. 45 minutes au fur à 120 °C.
Laisser refroidir entièrement (pas au réfrigérateur), saupoudrer de sucre brun et de sucre en poudre et gratiner. Décorer avec les fruits et la menthe.

l de nata
00 g de azúcar
rama de vainilla, abierta con un cuchillo
0 g de jengibre picado
tallo de pasto limón, machacado
yemas de huevo
cucharadas de azúcar marrón
cucharadas de azúcar en polvo
lechero de Bunsen para gratinar
utas y menta para decorar

Llevar a ebullición la nata, el azúcar, la rama de vainilla, el jengibre, el pasto limón, hervir a fuego lento durante cinco minutos y dejar reposar 30 minutos.
Batir las yemas de huevo y añadir el líquido caliente, que ya no está hirviendo. Pasar por un colador. Vaciar en moldes apropiados para el horno y escalfar a baño María a 120 °C durante aprox. 45 minutos.
Dejar enfriar completamente (no en la nevera), espolvorear con azúcar marrón y azúcar en polvo y gratinar. Decorar con frutas y menta.

l di panna
00 g di zucchero
i baccello di vaniglia, aperto
0 g di zenzero, tritato
gambo di erba cedrata, schiacciata
rossi d'uovo
cucchiai di zucchero marrone
cucchiai di zucchero a velo
ecco di bunsen per gratinare
utti e menta per guarnire

Cuocere per cinque minuti la panna, lo zucchero, baccelli di vaniglia, zenzero, erba cedrata e lasciar riposare per 30 minuti.
Sbattere i rossi d'uovo ed aggiungerli al liquido caldo ma non più bollente. Passare al setaccio.
Versare il tutto in una pirofila ed affogarlo in bagnomaria per circa 45 minuti a 120 °C.
Far raffreddare completamente (non nel frigo), cospargere con zucchero marrone e zucchero a velo e gratinare. Guarnire con frutta e menta.

Süllberg Bistro

Design: Synne Westphal, sw-Design
Chef: Ulrich Heimann, Karlheinz Hauser

Süllbergsterassen 12 | 22587 Blankenese
Phone: +49 40 8 66 25 20
www.suellberg-hamburg.de | info@suellberg-hamburg.de
Subway: Blankenese
Opening hours: Every day 11:30 am to 11 pm
Cuisine: World cuisine

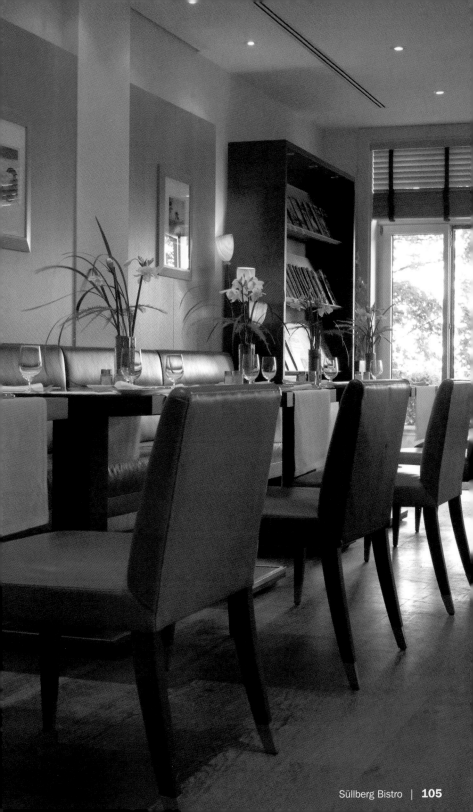

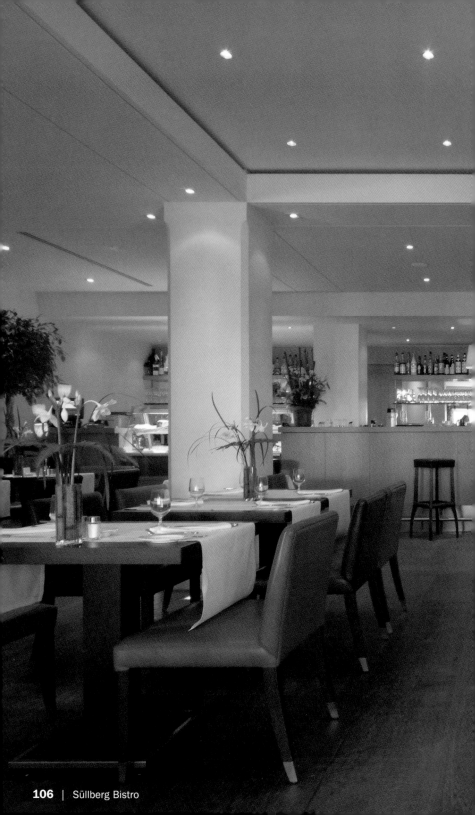

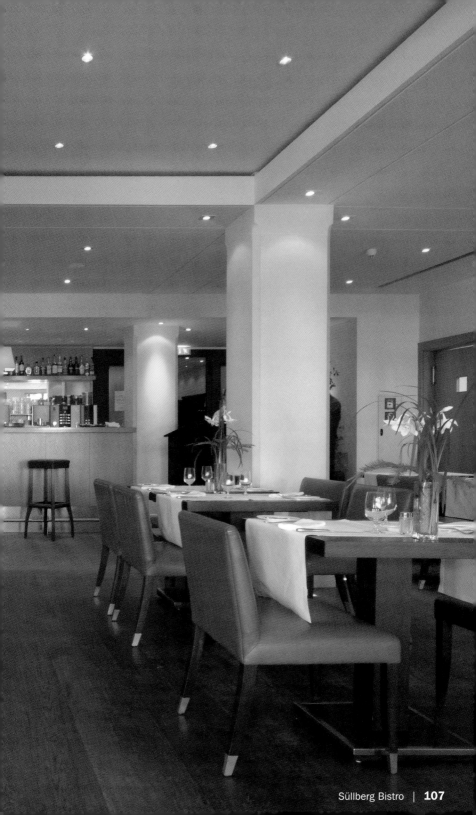

Turnhalle St. George

Design: Frank B. Theuerkauf | Chef: Nick Heitmann

Lange Reihe 107 | 20099 St. Georg
Phone: +49 40 28 00 84 80
www.turnhalle.com
Subway: Hauptbahnhof
Opening hours: Every day 9:30 am to open end
Average price: € 10
Cuisine: International, Mediterranean

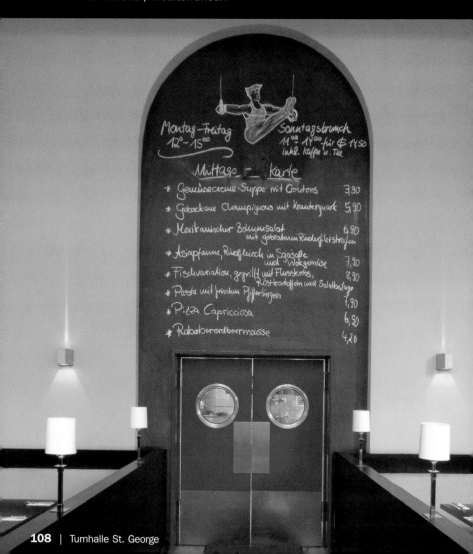

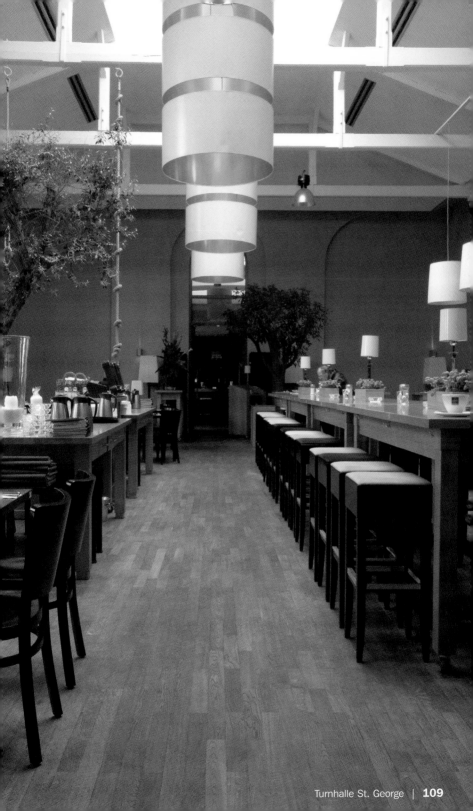

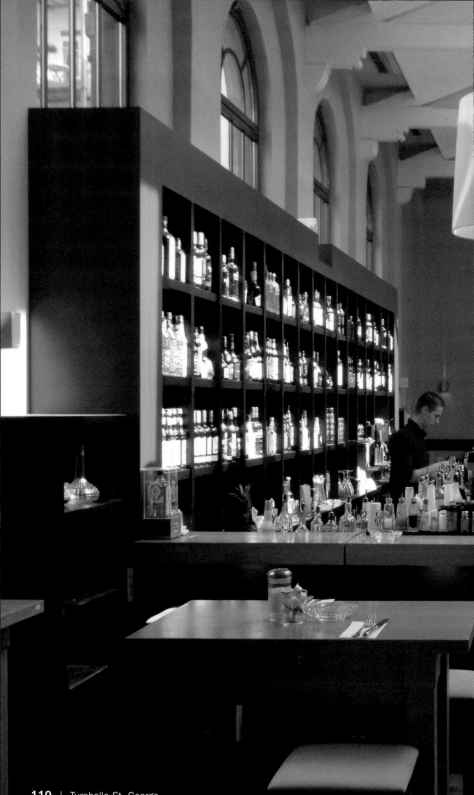

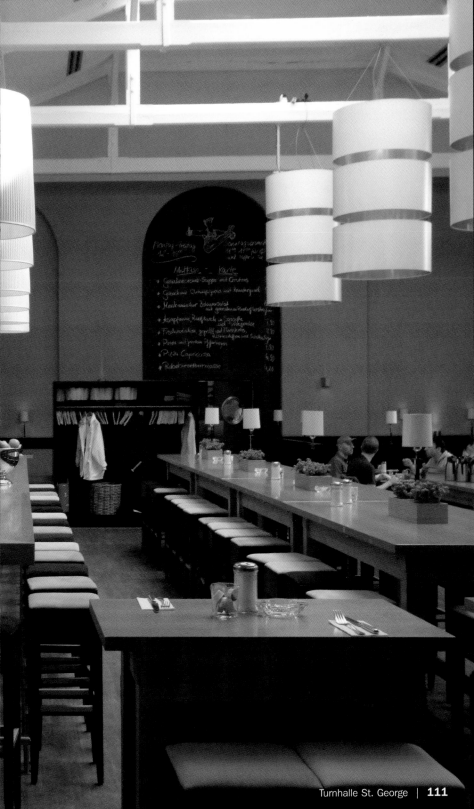

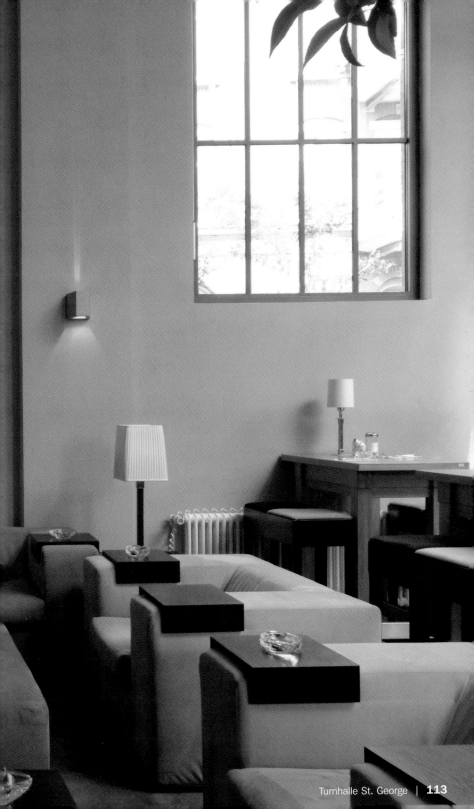

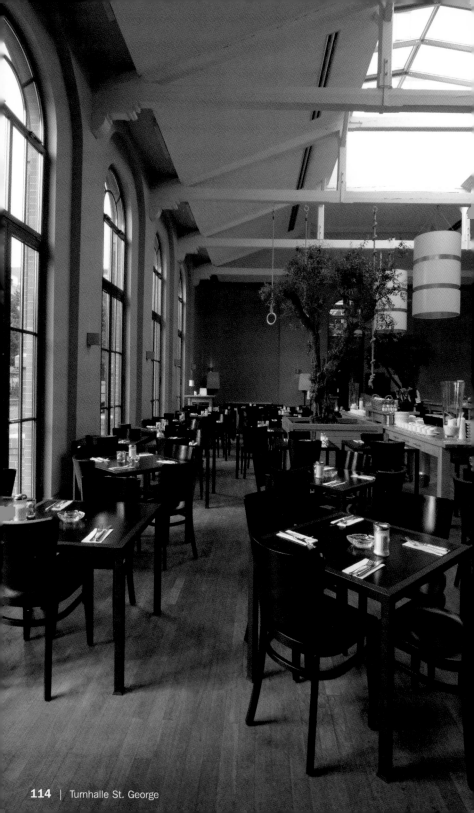

Passion Turner

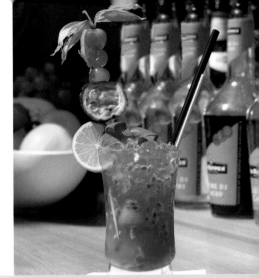

Limette
TL Rohrzucker
cl Limettensaft
cl Passoa
cl Wodka
cl Grenadine
rüchtespieß, Strohhalm

imetten achteln, mit dem Zucker in einem
ocktailglas zerstoßen und mit zerstoßenem Eis
uffüllen. Die restlichen Zutaten mischen und in
as Glas geben. Mit Früchtespieß und Strohhalm
arnieren.

lime
tsp cane sugar
cl lime juice
cl Passoa
cl vodka
cl grenadine
ruit pick, straw

ut lime in eight pieces, mash with sugar in a
ocktail glass and add crushed ice. Mix other
ngredients and pour in glass. Garnish with fruit
ick and straw.

1 limette
1 c. à café de sucre de canne
2 cl de jus de limette
2 cl de Passoa
3 cl de vodka
1 cl de grenadine
Brochette de fruits, paille

Couper les limettes en huit, les écraser avec le
sucre dans un verre à cocktail et remplir le verre
avec de la glace pilée. Mélanger le reste des
ingrédients et les verser dans le verre. Garnir avec
la brochette de fruits et la paille.

lima
cucharadita de azúcar de caña
cl de zumo de lima
cl de Passoa
cl de vodka
cl de granadina
inchito de frutas, pajita

artir la lima en ocho, triturarla con el azúcar en
un vaso de cóctel y llenarlo con el hielo triturado.
Mezclar el resto de los ingredientes y echarlos en
l vaso. Decorar con el pinchito de frutas y una
ajita.

1 limetta
1 cucchiaio di zucchero grezzo
2 cl di succo di limetta
2 cl di Passoa
3 cl di vodka
1 cl di grenadine
Spiedini di frutta, cannuccia

Dividere la limetta in otto parti, schiacciarla in un
bicchiere da Cocktail e riempire con ghiaccio stri-
tolato. Mescolare il resto degli ingredienti e ver-
sarli nel bicchiere. Guarnire con spiedini di frutta
e cannuccia.

Vapiano

Design: Matteo Thun | Chef: Jörn Sommer

Hohe Bleichen 10 | 20354 Innenstadt
Phone: +49 40 35 01 99 75
www.vapiano.de | info@vapiano.de
Subway: Gänsemarkt
Opening hours: Mon–Sat 11.30 am to 12 midnight, Sun 4 pm to 10 pm
Menu price: Pasta € 4.50–7.50, Pizza € 5.00–8.00
Cuisine: Italian, frontcooking

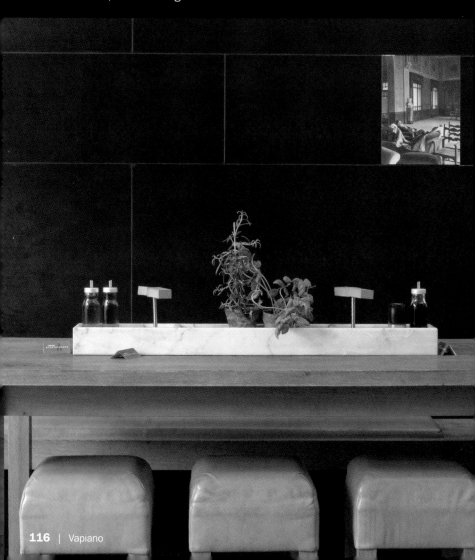

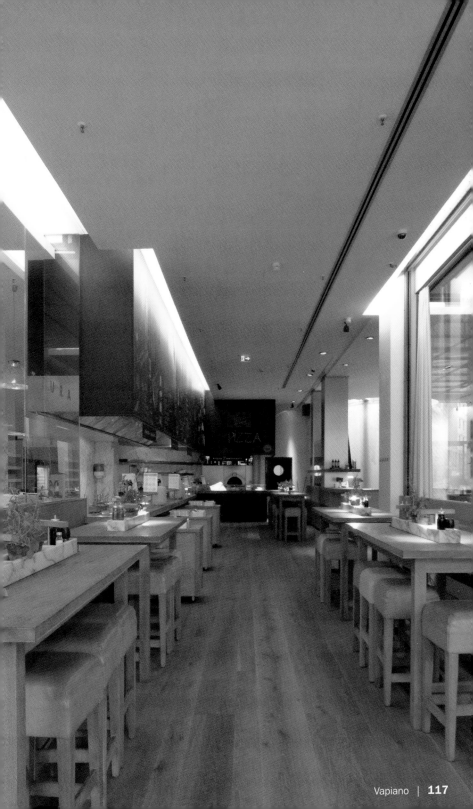

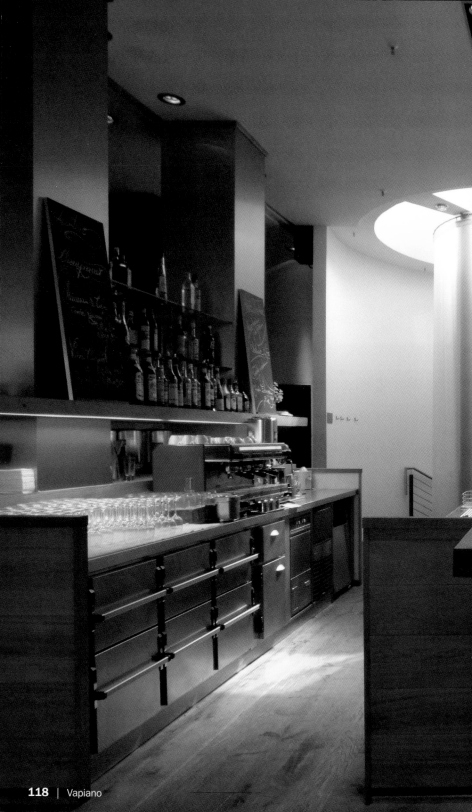

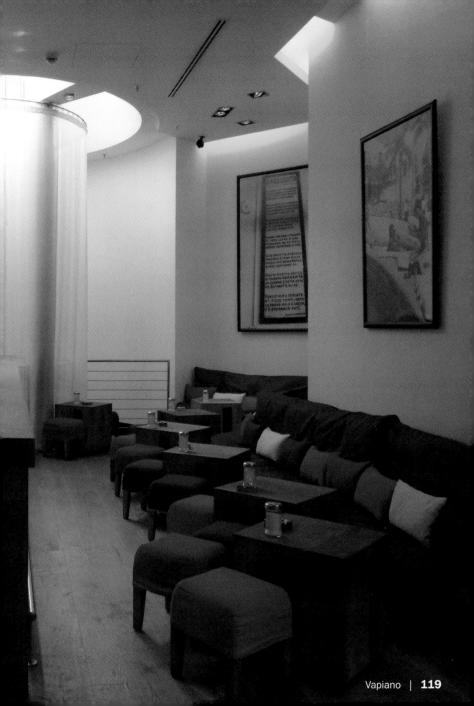

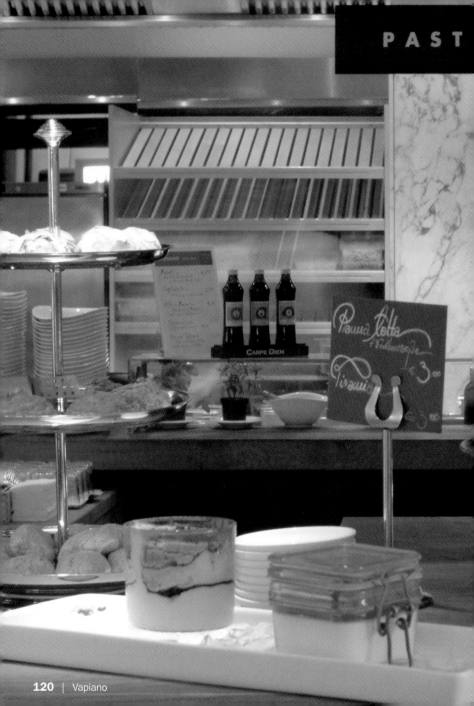

SALAT

Linguine
mit Rinderfilet und Ruccola

Linguine with Beef Filet and Ruccola
Linguine avec filet de bœf e roquette
Linguine con filete de ternera y rúcola
Linguine Filetto di manzo e rucola

800 g gekochte Linguine
300 g Rinderfilet in Streifen
1 kleine Zwiebel, gewürfelt
1 Frühlingszwiebel, in Ringen
1 Karotte, in Stiften
120 g Champignons, in Scheiben
1 kleine Zucchini, in Würfeln
50 ml Weißwein
120 ml Gemüsebrühe
5 EL Olivenöl
Salz, Pfeffer
120 g Ruccola
Frisch geriebener Parmesan
Basilikumblättchen

Filetstreifen mit Zwiebelwürfeln in Olivenöl ro
braten, würzen und aus der Pfanne nehme
Gemüse (außer Ruccola) in der Pfanne dünste
würzen und mit Weißwein und Gemüsebrü
ablöschen. Filetstreifen und Pasta zurück in
Pfanne geben und unterheben. Nun Rucc
untermischen, nochmals abschmecken, a
Tellern anrichten und nach Wunsch mit Parmes
und Basilikumblättern garnieren.

1 1/2 lb linguine, cooked
10 1/2 oz beef filet, cut in stripes
1 small onion, diced
1 spring onion, in rings
1 carrot, sticks
4 oz mushrooms, sliced
1 small zucchini, diced
50 ml white wine
120 ml vegetable stock
5 tbsp olive oil
Salt, pepper
4 oz ruccola
Fresh grated parmesan cheese
Basil leaves

Fry beef and onion in olive oil until medium, se
son and take out of the pan. Fry all vegetab
(except ruccola) in olive oil, add wine and vege
ble stock, season with salt and pepper. Put be
and pasta back in the pan and stir. Carefully f
in rucola, season again for taste and put
plates. Garnish with parmesan cheese and ba
leaves.

300 g de linguine cuites
300 g de filet de bœuf en lanières
1 petit oignon coupé en dés
1 oignon frais coupé en rondelles
1 carotte coupée en bâtonnets
120 g de champignons coupés en tranches
1 petite courgette coupée en dés
50 ml de vin blanc
120 ml de bouillon de légumes
5 c. à soupe d'huile d'olive
sel, poivre
120 g de roquette
Parmesan fraîchement râpé
feuilles de basilic

Cuire les lanières de filet, jusqu'à ce qu'elles soient roses, avec les dés d'oignons dans l'huile d'olive, assaisonner et les retirer de la poêle. Faire revenir les légumes dans la poêle (à l'exception de la roquette) et déglacer avec le vin blanc et le bouillon de légumes. Remettre les lanières de filet et les pâtes dans la poêle et mélanger délicatement. Ajouter la rouquette, assaisonner une nouvelle fois, dresser sur les assiettes et garnir, au choix, avec le Parmesan et les feuilles de basilic.

300 g de "linguine" (pasta larga de forma planada) cocido
300 g de filete de vaca en tiras
1 cebolla pequeña, en cuadraditos
1 cebolleta, en anillos
1 zanahoria, en barritas
120 g de champiñones, en rodajas
1 calabacín pequeño, en cuadraditos
50 ml de vino blanco
120 ml de caldo de verduras
5 cucharadas de aceite de oliva
sal, pimienta
120 g de rúcola
queso parmesano rallado fresco
hojitas de albahaca

Freír la tiras de filete con los cuadraditos de cebolla en aceite de oliva hasta que estén de color rosa, condimentar y retirarlos de la sartén. Rehogar la verdura (excepto la rúcola) en la sartén, condimentar y rebajar con vino blanco y caldo de verdura. Volver a poner en la sartén las tiritas de filete y la pasta y mezclarlos ligeramente. Ahora añadir y mezclar la rúcola, volver a sazonar, servir en los platos y según se desee decorar con parmesano y hojitas de albahaca.

300 g di linguine cotte
300 g di filetto di manzo tagliato a strisce
1 cipolla piccola, tagliata a cubetti
1 cipollotto, tagliato ad anelli
1 carota, tagliata a listelli
120 g di champignons, tagliati a fettine
1 zucchino piccolo, tagliato a cubetti
50 ml di vino bianco
120 ml di brodo vegetale
5 cucchiai d'olio d'oliva
sale, pepe
120 g di rucola
parmigiano grattugiato di fresco
foglie di basilico

Friggere in olio d'oliva le strisce di filetto con i cubetti di cipolle fino a farle diventare rosa, insaporire con sale e pepe e toglierle dalla padella. Stufare la verdura (eccetto la rucola) in padella, insaporire con le spezie e smorzare con il vino bianco e il brodo vegetale. Rimettere nella padella le strisce di filetto e la pasta e mescolare. Aggiungere la rucola e rimescolare, insaporire ancora, versare con mestolo nei piatti e a piacere guarnire con parmigiano e foglie di basilico.

WA–YO

Design: Matthias Sinios | Chef: Noboyuki Tobe

Hofweg 75 | 22085 Uhlenhorst
Phone: +49 40 2 27 11 40
www.nippon-hotel-hh.de | reservations@nippon-hotel-hh.de
Subway: Mundsburg
Opening hours: Tue–Sun 6 pm to 12 midnight, closed on Monday
Average price: € 15
Cuisine: Japanese

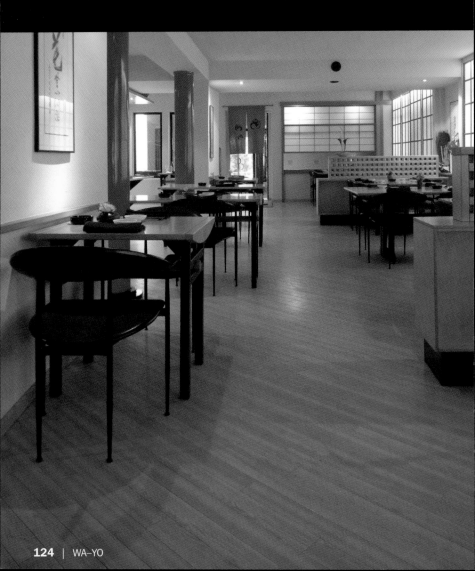

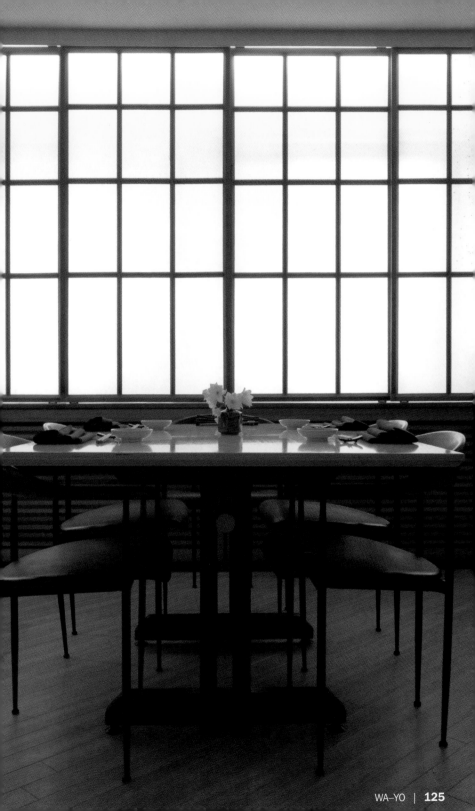

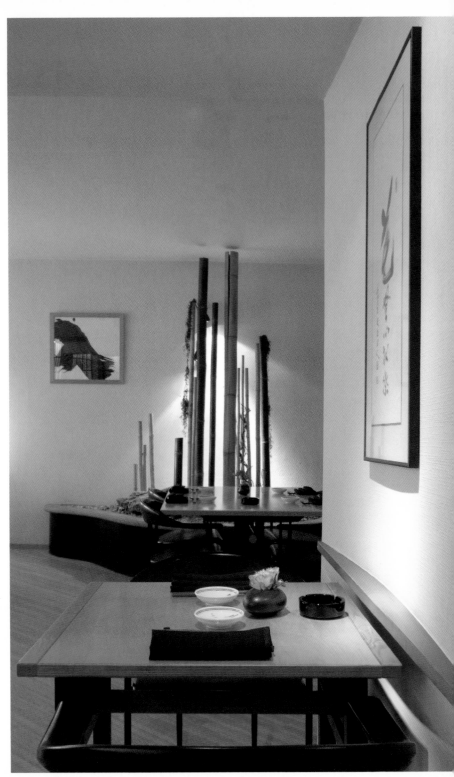

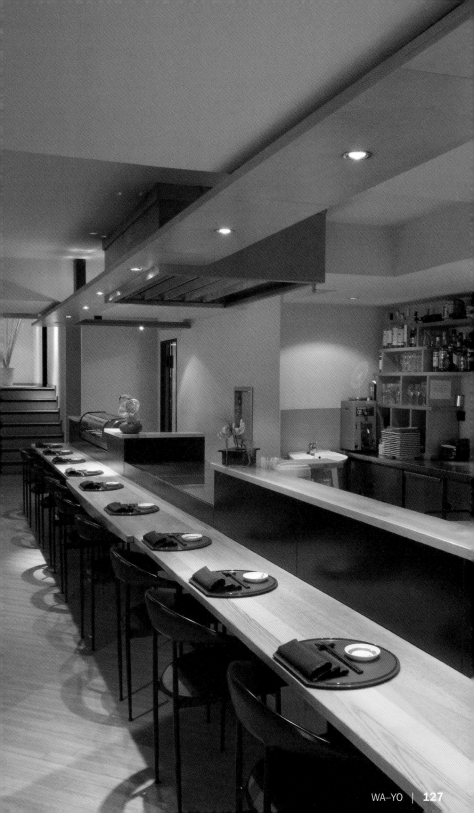

Gelbschwanz-Teriyaki

Yellow Tail Teriyaki

Teriyaki de buri

Pez limón-Teriyaki

Coda gialla-Teriyaki

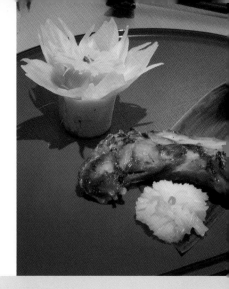

4 Gelbschwanzfilets mit Haut (à 220 g)
Salz
1 EL Öl

Teriyaki-Sauce:
240 ml Mirin (Süßreislikör)
160 ml Sake (Reiswein)
120 ml dunkle Sojasauce
3 EL Tamari-Sojasauce
Rettichblumen

Zutaten für die Sauce mischen und einmal star
aufkochen. Um 10% reduzieren lassen. Vom Her
nehmen.
Gelbschwanzfilets mit Salz bestreuen, 1
Minuten ziehen lassen, dann abspülen ur
trockentupfen. In der warmen Sauce marinieren
Filets aus der Sauce nehmen und in heißem (
von beiden Seiten goldbraun braten. Kurz vor der
Herausnehmen zwei EL Sauce zugeben und File
darin wenden.
Jedes Filet in zwei bis drei Stücke teilen, au
einem Teller anrichten, z. B. mit Rettichblume
etc. dekorieren.

4 yellow tail filets (7 oz each)
Salt
1 tbsp oil

Teriyaki sauce:
240 ml mirin (sweet rice liqueur)
160 ml sake (rice wine)
120 ml dark soy sauce
3 tbsp Tamari soy sauce
Radish roses

Combine all ingredients for the sauce in a pot an
bring to a boil. Let simmer to reduce 10%. Tak
off the stove.
Sprinkle yellow tail filets with salt and set aside fo
15 minutes, then rinse off, dry off and marina
in warm teriyaki sauce.
Take filets out off the sauce and fry in hot oil from
all sides until golden brown. Before taking ther
out add two tbsp sauce to the filets and turn th
fish.
Cut each filet in two to three pieces and put o
plates with a decoration, like radish roses, etc.

4 filets de buri avec la peau (à 220 g)
Sel
1 c. à soupe d'huile

Sauce Teriyaki :
240 ml de mirin (liqueur de riz sucré)
160 ml de sake (vin de riz)
120 ml de sauce soja foncée
3 EL de sauce soja Tamari
Fleurs de radis blancs

Mélanger les ingrédients pour la sauce et amener une fois à ébullition. Faire réduire de 10%. Enlever du feu.
Saupoudrer les filets de buri de sel, laisser pendant 15 minutes, rincer et essuyer. Les laisser mariner dans la sauce chaude.
Retirer les filets de la sauce, conserver la sauce. Faire frire les filets des deux côtés dans de l'huile chaude jusqu'à ce qu'ils soient dorés. Juste avant de les retirer, ajouter deux c. à soupe de sauce et retourner les filets dans la sauce.
Couper chaque filet en deux ou trois morceaux, les dresser sur une assiette et les décorer, par ex., avec des fleurs de radis blancs, etc.

4 filetes de pez limón con piel (c/u 220 g)
Sal
1 cucharadas de aceite

Salsa Teriyaki:
240 ml de mirin (licor de arroz dulce)
160 ml de sake (vino de arroz)
120 ml de salsa de soja oscura
3 cucharadas de salsa de soja Tamari
Flores de rábano

Mezclar los ingredientes para la salsa y dar un fuerte hervor, para hacerla reducir en 10%. Quitarla de la cocina.
Espolvorear con sal los filetes de pez limón, dejarlos reposar 15 minutos, luego enjuagarlos y secarlos. Escabecharlos en la salsa caliente. Retirarlos de la salsa, conservar la salsa. Freír los filetes en aceite caliente por ambos lados hasta que estén pardo-dorados. Poco antes de sacarlos añadir dos cucharadas de salsa y dar vuelta los filetes en ella.
Dividir los filetes en dos o tres trozos y servirlos en un plato, y decorarlos por ejemplo con flores de rábano etc.

4 filetti di coda gialla con pelle (da 220 g l'uno)
Sale
1 cucchiaio di olio

Salsa Teriyaki:
240 ml di mirin (liquore di riso dolce)
160 ml di sake (vino di riso)
120 ml di salsa di soia scura
3 cucchiai di salsa di soia Tamari
Fiori di rafano

Mescolare gli ingredienti per la salsa e farli cuocere a fuoco vivo fino a ridurli del 10%. Toglierli dal fuoco.
Cospargere di sale i filetti di coda gialla, lasciar macerare per 15 minuti, risciacquare ed asciugare. Marinare nella salsa calda.
Togliere i filetti dalla salsa e mettere da parte la salsa. Friggere i filetti in olio bollente da entrambi i lati fino a renderli dorati. Poco prima di toglierli aggiungere due cucchiai di salsa e rotolarvi i filetti. Dividere ogni filetto in due o tre pezzi, metterli su di un piatto e guarnirli per es. con fiori di rafano.

Weite Welt

Design: Francesca Bornhofen | Chef: Roland Marap

Große Freiheit 70 | 22767 St. Pauli
Phone: +49 40 3 19 12 14
www.weite-welt.de | info@weite-welt.de
Subway: Reeperbahn
Opening hours: Mon–Thu 6 pm to 1 am, Fri–Sat 5 pm to 3 am,
Sun 5 pm to 12 midnight
Average price: € 35
Cuisine: International

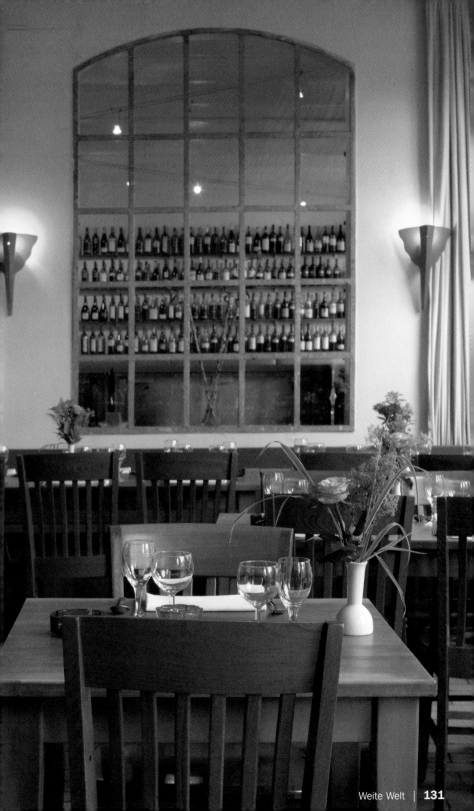

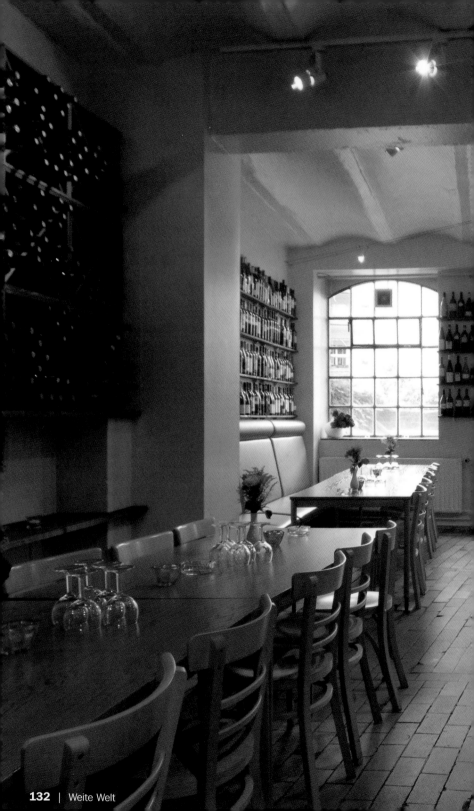

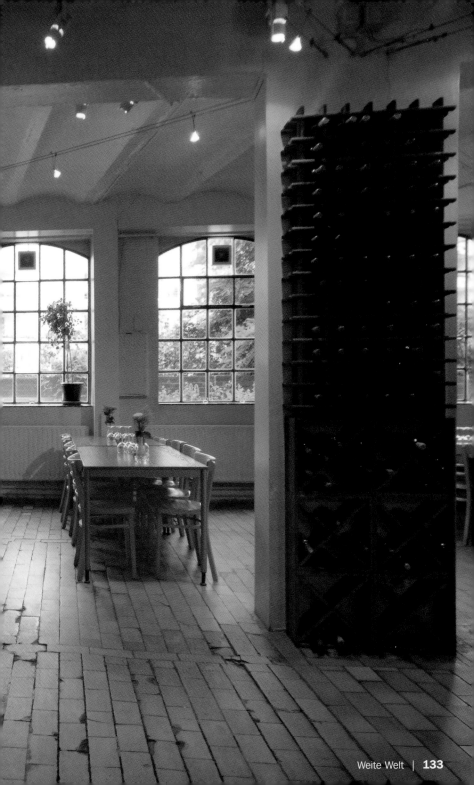

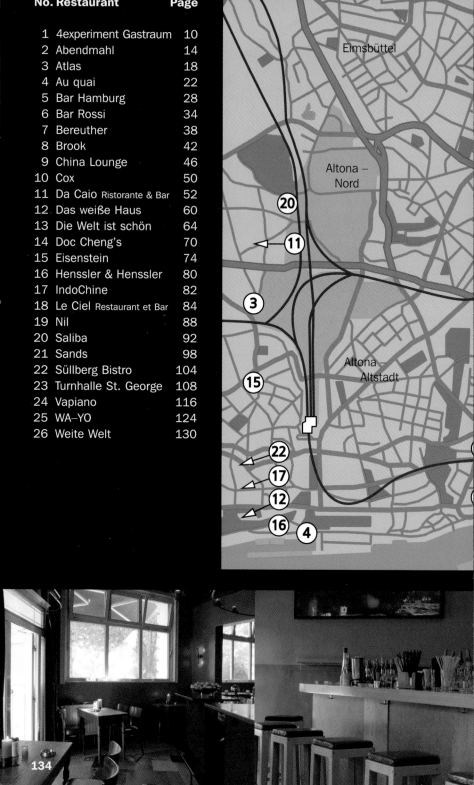

Eimsbüttel

Altona – Nord

Altona – Altstadt

134

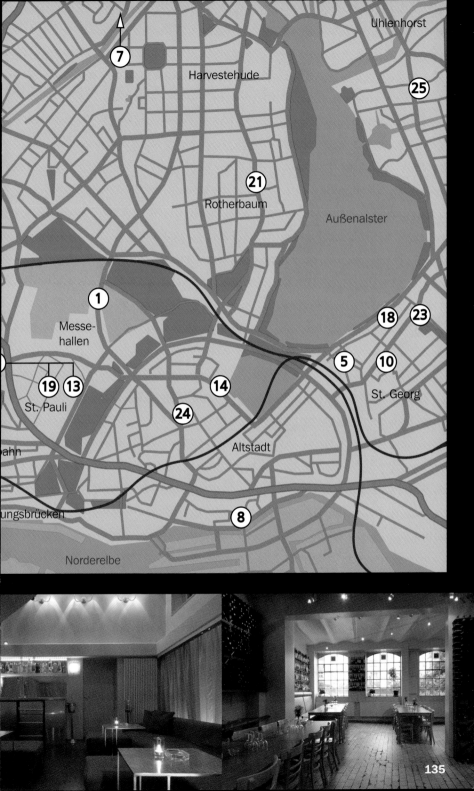

Cool Restaurants

Size: 14 x 21.5 cm / 5 1/2 x 8 in.
136 pp
Flexicover

c. 130 color photographs
Text in English, German, French,
Spanish and (*) Italian

Other titles in the same series:

Amsterdam (*)
ISBN 3-8238-4588-8

Barcelona (*)
ISBN 3-8238-4586-1

Berlin (*)
ISBN 3-8238-4585-3

London
ISBN 3-8238-4568-3

Los Angeles (*)
ISBN 3-8238-4589-6

Milan (*)
ISBN 3-8238-4587-X

New York
ISBN 3-8238-4571-3

Paris
ISBN 3-8238-4570-5

Tokyo (*)
ISBN 3-8238-4590-X

To be published in the
same series:

Brussels
Chicago
Geneva
Madrid
Miami
Moscow

Munich
Rome
Stockholm
Sydney
Vienna
Zurich

teNeues